STILL RAININ' ❖ STILL DREAMIN'

© 2010 University of Alaska Press
All rights reserved

University of Alaska Press
P.O. Box 756240
Fairbanks, AK 99775-6240

ISBN 978-1-889963-90-7

Library of Congress Cataloging-in-Publication Data

Anderson, Hall.
Still rainin', still dreamin' : Hall Anderson's Ketchikan.
p. cm.
ISBN 978-1-889963-90-7 (pbk. : alk. paper)
1. Ketchikan (Alaska)—Pictorial works. 2. Ketchikan (Alaska)—
Social life and customs—Pictorial works. I. Title.
F914.K4A53 2010
979.8'2—dc22
2010010386

This publication was printed on acid-free paper that meets the minimum requirements for
ANSI / NISO Z39.48–1992 (R2002) (Permanence of Paper for Printed Library Materials).

Ketchikan Daily News photos printed with permission of Pioneer Printing Co., Inc.
Cover and interior design by Alcorn Publication Design

Printed in China

STILL RAININ' ❖ STILL DREAMIN'

HALL ANDERSON'S KETCHIKAN

FOREWORD BY
BRAD MATSEN AND RAY TROLL

UNIVERSITY OF ALASKA PRESS
FAIRBANKS

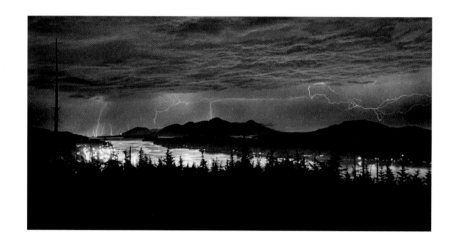

To my mother, Bernice Anderson, who always believed.

FOREWORD: HALL ANDERSON'S PARIS

BRAD MATSEN AND RAY TROLL

T he odds against a great photographer taking a job on a small-town daily newspaper into which he invests his entire artistic career are a million-to-one. Almost always, the most talented tire of the deadline grind, low wages, and long hours. They move on to bigger papers or abandon the news business in favor of less demanding work. Hall Anderson took a job at the *Ketchikan Daily News* in 1984 and, to our great good fortune, he never left. For more than a quarter of a century, he has photographed Fourth of July parades, logging rodeos, elections, storms, heartbreakingly bright days, salmon derbies, and all the tragedies and joys of life from which we would have been excluded without the presence of his masterful eye and his camera. To tens of thousands of people who have lived in Ketchikan—whether they passed through for a season of work or settled to make lives there—Hall Anderson's photographs are as indelible as the events themselves. Now, a hundred of those pictures in this book testify to his serendipitous genius. There are few,

if any, collections of photographs taken over generations of time with the insight, kindness, and devotion that Hall put into these.

The unlikely cascade of circumstances that brought Hall Anderson to Ketchikan and kept him there began in 1961, when he used his mother's Kodak Brownie Starflash to photograph the sweet urban vistas of San Francisco during a family vacation. Hall was twelve years old, a member of one of the first American generations whose entire lives would be recorded in photographs. Composing images of cable cars, the Embarcadero, and Coit Tower through the viewfinder of the Starflash—knowing that he would later be holding those black-and-white pictures of San Francisco in his hands—was irresistible alchemy to the son of a lawyer from Oregon's Willamette Valley.

At first, Hall's attraction was to the technical process of creating a photograph as much as anything. Back home in Salem, he began to haunt the home of a friend whose father

had a real camera—a Leica—and a darkroom. The tools and aromas of the darkroom—film tanks, enlarger, developer, stop bath, and fixer—sustained him through adolescence as the pictures he took became photographs instead of snapshots.

When Hall arrived at the University of Oregon in Eugene, he found his first mentor in Bernard Freemesser, a celebrated photographer whose deep passion for the western territories informed his large-format landscapes. Freemesser was a fiercely opinionated man who cherished his place in the lineage of Ansel Adams, Edward Weston, and Brett Weston. He also made sure his students appreciated the fact that Kodak film and paper was inferior, that only Agfa and Ilford papers produced black blacks, that black-and-white film was far superior as an interpretive medium than color, and that Amidol developer was better than Dektol. (Adams, and the Westons, too, used Amidol.) In addition to welcoming Hall into his workshops and the legendary critique sessions in his home, Freemesser's outspoken opinions set Hall on his way to a kind of practical perfectionism in every frame he shot.

Hall's interlude with Bernie Freemesser, big cameras, and landscapes ended before graduation when he met John Bauguess, who also had studied with Freemesser. Bauguess countered his teacher's passion for large-format cameras with his own for the speed and immediacy of a 35mm Leica. Bauguess, and his new friend Hall Anderson, were charmed by the work of Henri Cartier-Bresson and his declaration that capturing the decisive moment is the single most important artistic purpose for a photographer. The power contained in photographs of ordinary people at extraordinary moments in their lives on the streets of Eugene and Paris set the course for the rest of Hall's professional life.

In 1980, Hall applied to his first newspaper, the *Willamette Valley Observer* in Eugene. He was one of three finalists, but didn't get the job. For the next three years, photography remained the increasingly obsessive center of his life. However, he was working as a retort operator in a bean cannery to make a living. Like most young men growing up in the Pacific Northwest, the allure of seasonal work in Alaska was always an ace in the hole for Hall. He had discovered Ketchikan in 1977, arriving in a Volkswagen square-back with college friends, and from then on figured that if things didn't work out in the real world, he could always find work up north.

In 1980, work and photography in Alaska finally intersected for Hall when he found a job with the Southeast Island School District running photo workshops in Port Alexander on the southeastern tip of Baranof Island. He built

a darkroom in a school bathroom, and taught students and parents how to shoot and print their own pictures. The following fall, he took his show on the road to a logging camp in another small coastal town, but Ketchikan—where he began and ended each trip—was becoming the center of his world. He was never without his camera, and the little city at the bottom of Alaska was becoming his Paris.

In the summer of 1983, Hall Anderson walked into the newsroom of the *Ketchikan Daily News* and asked the editor whether he was buying freelance photographs. The editor said not too many, but he just happened to need a photographer for a few days until the newly hired staff photographer arrived.

The week on the paper was routine. Check into the newsroom in the morning, get a list of stories, take pictures, develop film, make prints. The summer days were twelve, sometimes sixteen, hours long, but Hall had found the home that would nurture him.

One year later, after another temporary job on the paper in the summer of 1984, Hall became the staff photographer for the *Ketchikan Daily News*. Since then, he has shot and developed more than a thousand rolls of film every year, selecting the best for the pages of the newspaper. The people of Ketchikan caught on to

Hall's talent and dedication early on, gave him more and more access to their lives and hearts, and enjoyed the photographic treasures that graced every day in the *Daily News*.

Looking at one of Hall's photographs, we sense that a keen compositional eye is at work, elements in the frame balanced and dynamically arranged. Hall specializes in "street grabs" frequently shot from the hip or, more often, instantly composed in the viewfinder. His uncanny ability to recognize the charged, fleeting moments in the daily life of a small town produces images that seem like dramatic moments from the eye of a whimsical film director.

Hall seems like Hitchcock sometimes, enamored of the dark possibilities in everyday scenes and yet sly and wry enough to throw in levity here and there as the drama plays out. There is an ominous *Twilight Zone* feel to the very formal-looking nighttime photo "Cadillac Garage" (page 53), with dark shadows of tree branches crawling across the foreground. Right across from it in the pages of this book, "Abandoned Cowboy Town, Ketchikan Landfill" (page 52) reveals his lighthearted and whimsical sensibility.

At other times Hall seems like Frank Capra in photos such as "Stedman Street Bridge" (page 13), or "First Day of School" (page 69) conveying a unique sense of small-town

American optimism. Conversely, a David Lynch–like sense of dark, surrealistic humor pervades photos such as "Lion in Winter" (page 75) or "Parade Spectators, Fourth of July" (page 103).

Hall has studied and learned from the world's best photographers and often pays homage to his heroes. His tent city photos riff on Dorothea Lange's Oklahoma migrant photos. "Tourists and Canine Driver" (page 56) is pure Elliot Erwitt at his laugh-out-loud best. "Spectator, Pioneer Hotel" (page 109) is a nod to Robert Frank, "Heavy Load" (page 51) to Lee Friedlander, and "Downtown park, Thundering Wings Totem" (page 34) to Gary Winogrand.

But it is Hall's twenty-five years of on-the-job experience as a spontaneous storyteller that ultimately shines through in a style all his own. "Fourth of July" (page 14) which was taken shortly after his arrival in Alaska, looks random at first glance. Then you'll notice it falls into the "law of thirds," with three figures shifted off to the right, one looking back toward the left-hand two-thirds. There are three figures on the far left engaged in a mysterious transaction involving a bag. They are younger people, two of them in Coast Guard uniforms. Another figure approaches from the distance, crossing a bridge. The horizon line is shifted toward the upper third of the frame with broad swaths running horizontally as you look to the foreground.

But what is going on here? The tired-looking guys at the right are older men who look completely worn out. One's hat is on the ground in front of him. The fellow on the far right looks beaten, a little like someone on hard times in a 1940s film. The guy in the middle looks like Fred Mertz, the neighbor from *I Love Lucy*. The Native American man holding the American flag sports a 1950s-style slicked-back hairdo. They're anachronisms now in a shifting world. What kind of lives have they led? Are they veterans who have just marched a bit too far in the annual parade? Are their wartime experiences written on their faces? Are any of them still alive today? And just what exactly is that Coast Guard guy looking at in the bag? Overhead, a moody, heavy, gray southeast Alaska sky casts a somber tone on the whole scene. Hall has captured an entire world shifting between generations in one seemingly random shot.

"Cannery Workers at Home in Tent City" (page 15) also falls into the law of thirds, with the guy smirking on the right, a happy, hard-working couple at the center, and milk cartons and clothes strung all about on the left. The composition is impeccable, but it also borders on the edge of chaos. Once again Anderson's storytelling shines through.

You don't notice the school bus at first, but there it is, parked for the summer as a residence for these itinerant cannery workers. Who are the people in the shot and what is happening at that precise moment in their lives? What has Hall walked into? What are they thinking of this guy holding the camera in their faces?

Hard-working Ketchikan plays out before our eyes in these pages. Loggers, fishermen, construction workers precariously balanced on beams. Floatplanes lined up at dawn. Gigantic cruise ships looming over the waterfront with hand-carved canoes sliding gracefully before them. For a quarter century, Hall Anderson has captured the streets of this island town with his roving camera, recording the slow process of history transforming the town he lives in and aging the friends he has made.

A younger Nathan Jackson, Tlingit master carver, peers over his eyeglasses as he carves a raven mask, looking like the wise trickster raven that he is. A youthful Israel Shotridge beams with pride as he puts the last touches on his first monumental totem pole back in 1989. A shot of three guys putting up a new sign on a bar's roof is transformed into an epic work of art by Hall's eye. The Ohashi family sitting elegantly on barstools at the soda fountain they ran for decades is only a memory now, preserved by Hall's carefully composed photograph. Clara Diaz smiling behind the counter at Diaz Café. Jay Miller looking up to his father on career day. First haircut. First day at school. Boys frolicking on a salmon weir in Ketchikan Creek. Chandra Travers turning to a friend in a sea of faces during high school graduation ceremonies. Head Start kids squirming on the stage in Saxman. Bone-weary cannery workers taking a break. A man grieving before the traveling Vietnam Memorial wall.

Ketchikan and its people have aged and grown before Hall's eyes. Their joy, grief, bliss, silliness, pride, fear, wonder, weariness, and whimsy are his photographic world. He has recorded life in a small town on a rain-swept rock in the North Pacific, and that small town has been made so much the better for it. What an absolute joy it has been for the people of Ketchikan to see Hall Anderson's masterpieces greeting them every day on the pages of their local newspaper. Now we can share the pleasure.

PHOTOGRAPHER'S NOTE

For nearly fifty years I have been intrigued by the inherent drama in natural and urban landscapes and in the ways ordinary people interact with their surroundings. I am fascinated by the unintentional choreography and the uncanny juxtapositions in everyday life.

I love the discovery of the moment and applying a sense of order and design to events unfolding before my view-finder. Part of the rush for me is encountering that unscripted drama as I step out onto the street. Often I shoot from the hip with little forethought, knowing I'm on to something. I work it.

Sometimes it's easy, other times it's much harder, but I keep going for it until I think I've got it.

Only later, when I return to the darkroom (or the computer), does the real discovery begin. Finding that one magical moment truly makes my day.

Photography has always been a way for me to discover and explore the drama and to document the dance. The camera keeps me grounded to my place in the world as an observer, as a participant, and as a chronicler of my extraordinary life here in a small town in Southeast Alaska.

ACKNOWLEDGMENTS

About fifteen years ago, I was playing around with the idea of a book featuring my black-and-white photos of Ketchikan. The project was reinforced by friends who attended a weekly brown-bag lunch—"Mr. A's Lunch Club"—at my apartment in the 1990s. Thanks for always believing that the book would be a reality. Ray Troll, a club regular, gave me encouragement and some ideas to get the ball rolling.

The University of Alaska Press took a special interest in the project. Brad Matsen, tirelessly promoted the idea.

Little did I know how much work was necessary to produce such a book. The project involved a host of people and many hours of research—going through negatives, selecting possibilities, and scanning several hundred prospects before making the final selections. The scanning process alone took four years.

Now that the book is a reality, I want to recognize the players who contributed to making it possible.

Special acknowledgment must go to my friend Ray Troll, because without his energy, constant prodding, and belief in the book, it never would have happened. He has been with me as an adviser and source of inspiration from day one. He also helped with the demanding photo-editing process, along with my Oregon photographer friend, John Bauguess.

Having Bauguess on the project was important to me, because our history as fellow photographers precedes my Alaska days. Bauguess was a mentor who helped show me the way as a photographer of the "unscripted drama" we often found in the late 1970s on many photo expeditions along country roads off the interstate in Oregon's Willamette Valley. Ketchikan photographer Chip Porter also helped in the photo-editing process and gave valuable input on the photo sequencing. Bob Weinstein and Gregg Poppen used their knowledge of computers to make invaluable contributions. Weinstein came through many times at the eleventh hour to fix software snafus and help with computer and software upgrades. Weinstein also helped jumpstart my photography career in 1979, when he was superintendent of the Southeast Island School District,

by hiring me through the Artists in the Schools program to teach photography in small, remote schools. Poppen shared his vast knowledge of Adobe Photoshop to help make challenging adjustments to some of the image scans. My *Ketchikan Daily News* editor, Terry Miller, edited my writing to help make it presentable to the book publishers and the curators of my museum show.

I would like to give special thanks and recognition to the Williams family, owners of Pioneer Printing Co., Inc., and publishers of the *Ketchikan Daily News*. Not only have they given me the time and opportunity to find and develop my vision, they have given the book their support. They helped make its publication possible by allowing me to use many of the photographs I took as a staff photographer with the *Daily News* over the past twenty-five years.

I would like to acknowledge my webmaster, Craig Koch, of Narrows Perch Studios, for getting my website ready in time for the museum show, which featured photos from the book. I would also like to thank Terry Pyles for the beautiful prints he made for that show. And Adam Welz, who provided much-needed inspiration at the right time. The Rasmuson Foundation also deserves acknowledgment, both for its consistent support of the arts in Alaska and for its specific support of this book with a generous project award in 2007. Thanks to Sara Lawson, former executive director of Ketchikan Area Arts and Humanities Council, who advised me on the grant writing process.

The people of Ketchikan should be thanked, too, for putting up with me as I attempted to capture the history of what started out as their town—now our town—through my eyes for the past twenty-five years.

Finally, I would like to mention the women who have made a difference in my life and in doing so also contributed to this book. My gratitude and special thanks go to Selina Roberts-Ottum, former director of the Lane Regional Arts Council in Eugene, Oregon, who had the vision to give me my first job as a photographer in 1979.

I would also like to thank former *Ketchikan Daily News* editor Heidi Ekstrand, who hired me in 1984 as a full-time photographer.

Finally, I must recognize my wonderful wife, Terri Robbins, for her endurance, unconditional support, and never jumping ship—even though at many times it appeared that this project would never stay afloat. Terri has also contributed by editing and constructive feedback. Terri, you are the one!

❖

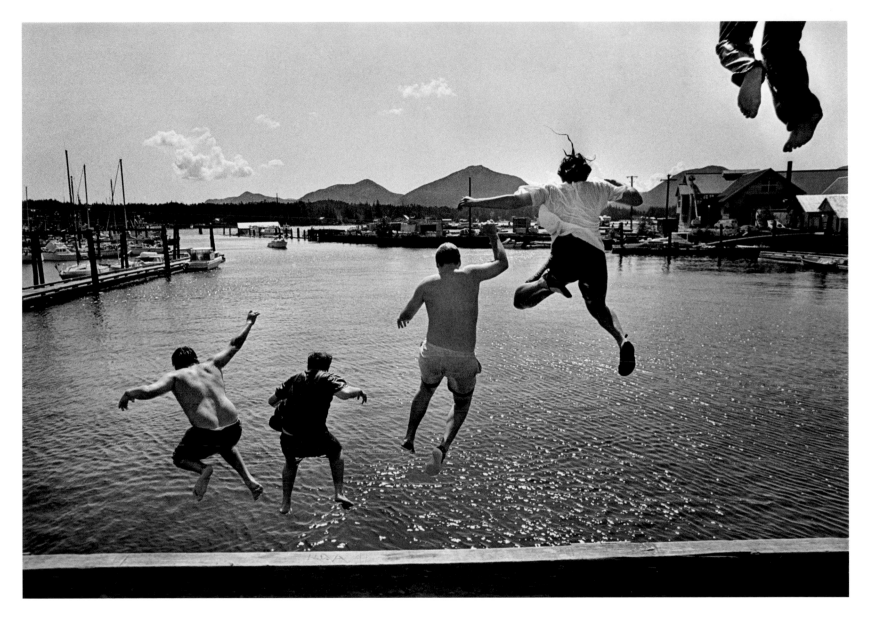

Stedman Street Bridge,
Thomas Basin.
July 19, 1993.

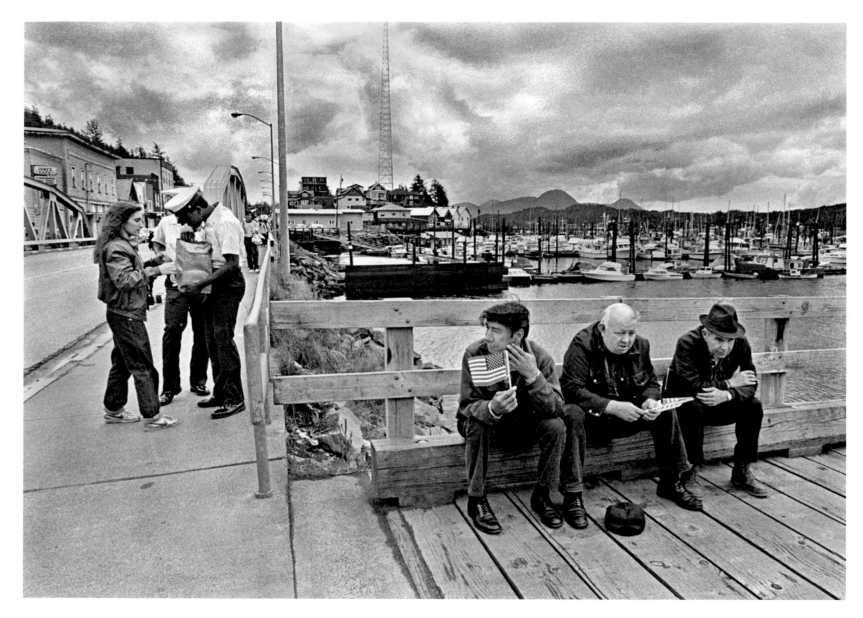

Fourth of July, Thomas Basin. 1983.

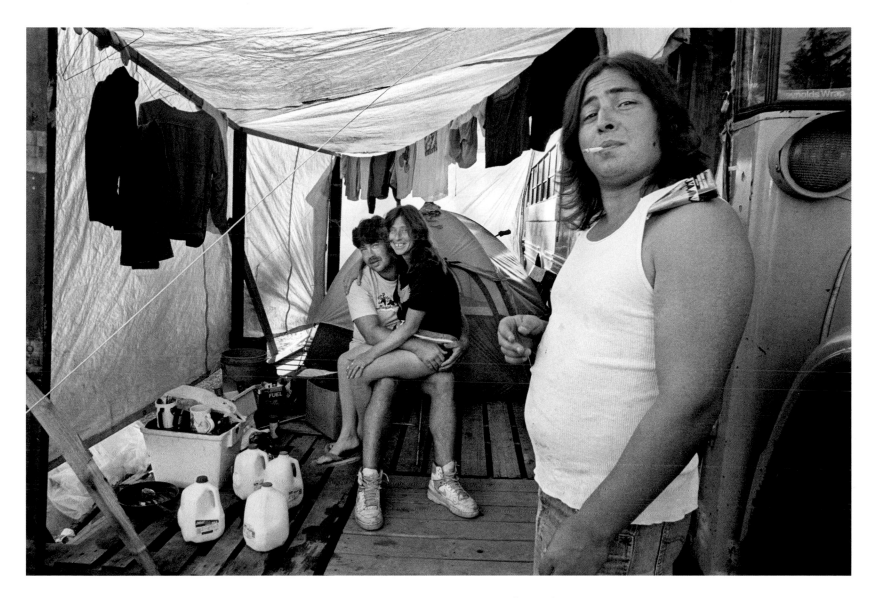

Cannery workers at home in
Tent City. July 29, 1990.

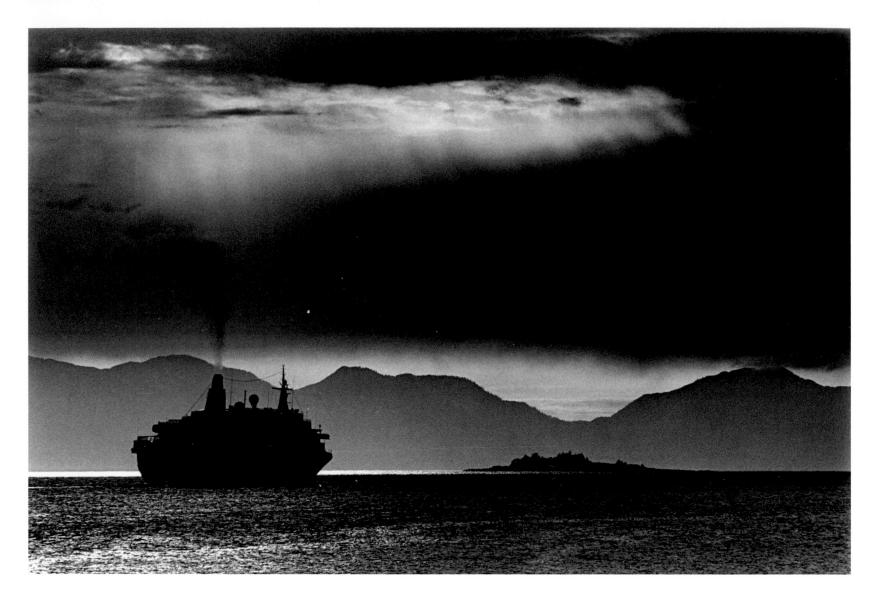

Cruise ship *Tongass Narrows* near
Guard Island. May 18, 1996.

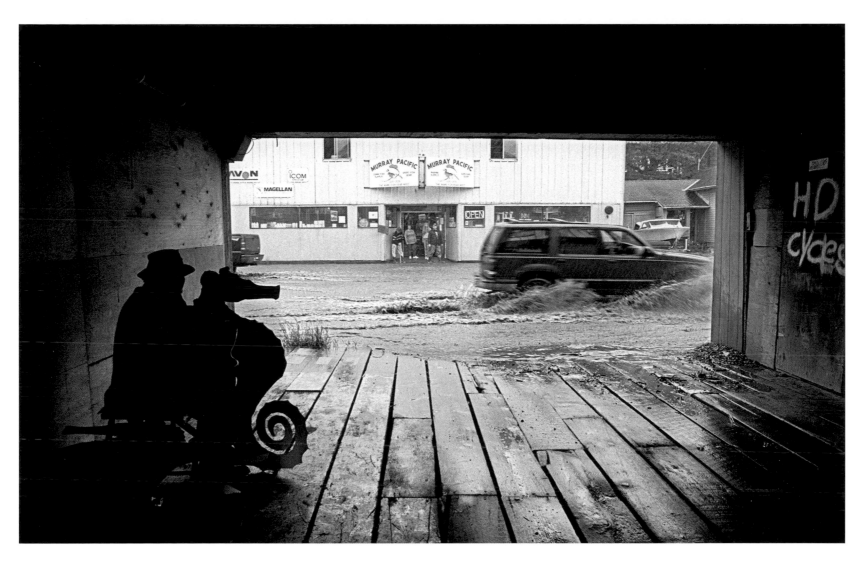

Artist Dave Rubin in Waterfront
Storage after unusual rains.
July 24, 2000.

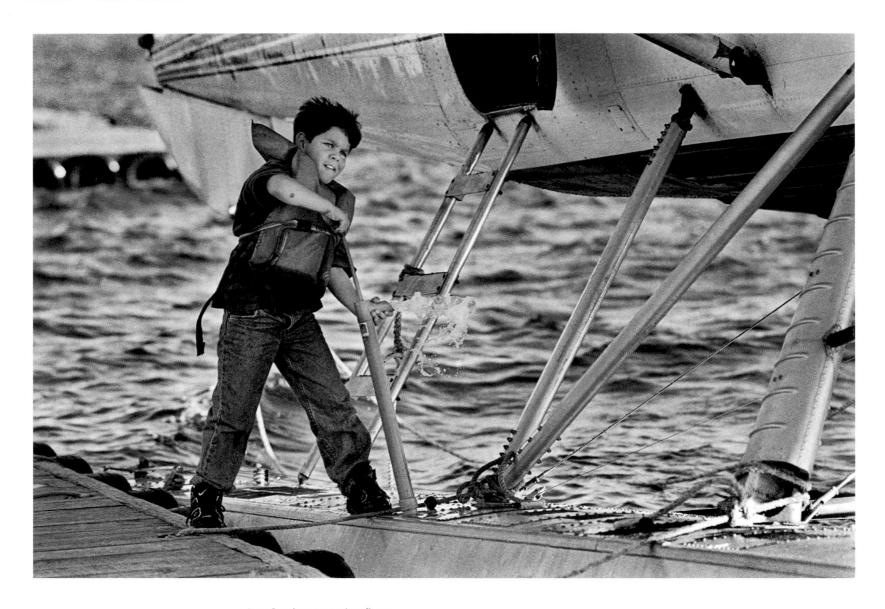

Jase Scudero pumping floats.
September 17, 1997.

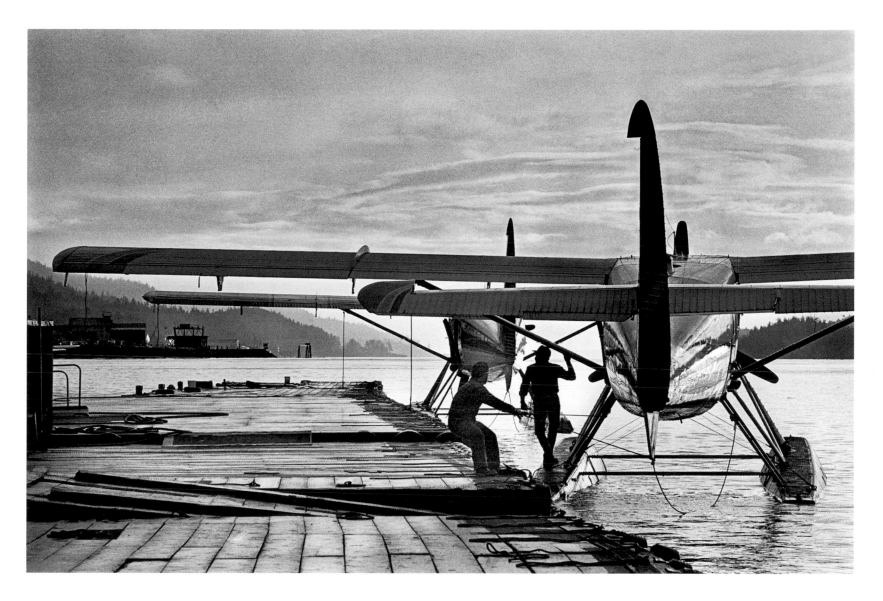

Floatplane dock, downtown
Ketchikan. December 11, 1987.

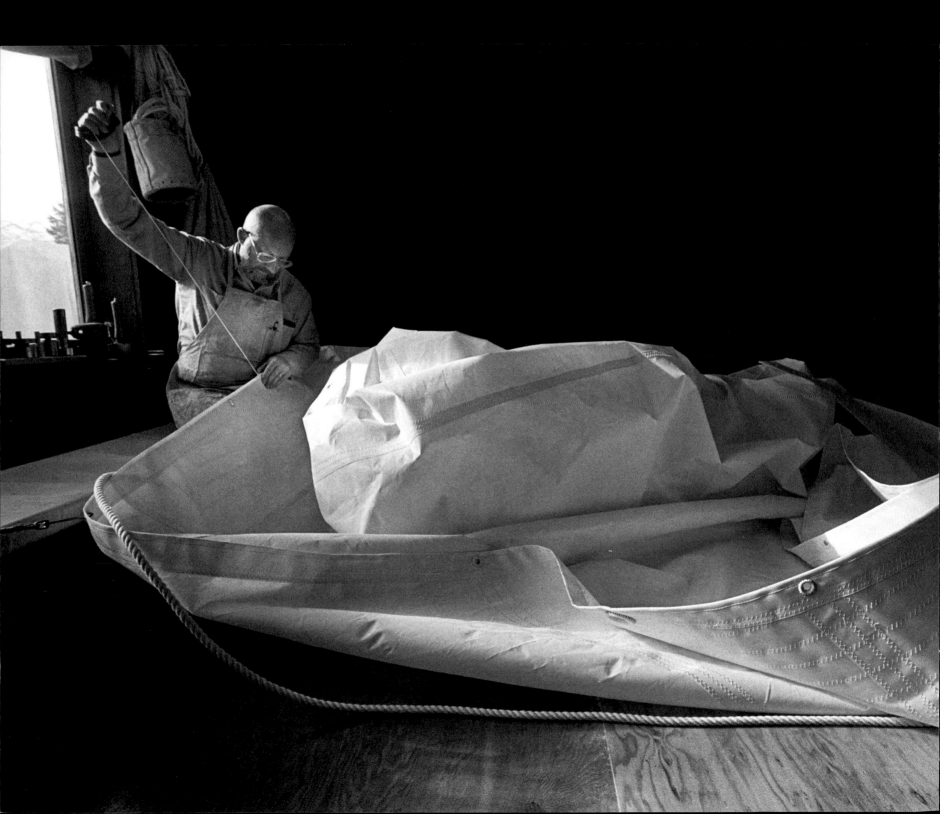

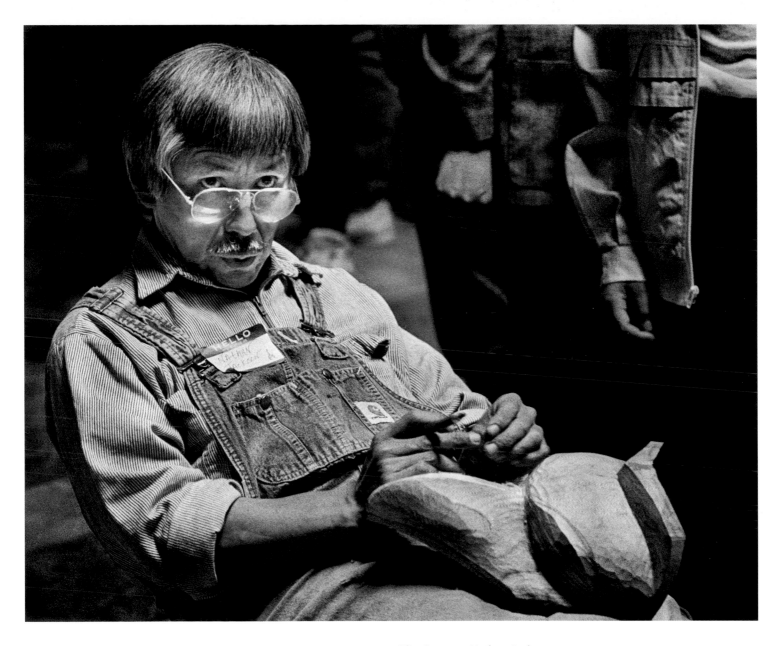

Sailmaker Louis Bartos.
March 26, 1988.

Tlingit carver Nathan Jackson,
Tribal House in Saxman.
May 14, 1989.

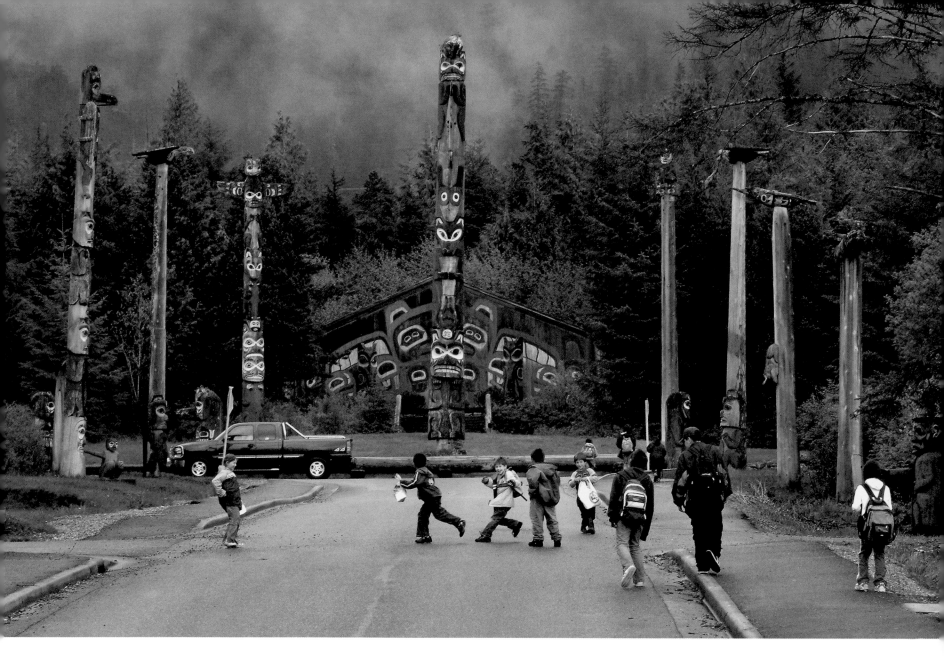

After school in Saxman.
May 12, 2003.

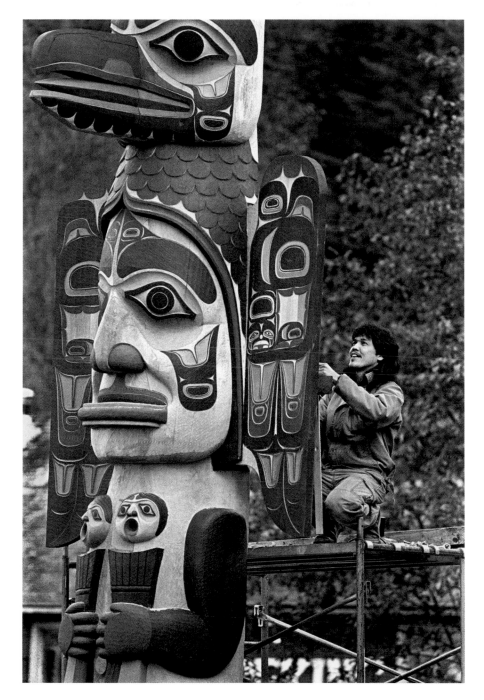

Israel Shotridge finishes
Chief Johnson pole.
October 10, 1989.

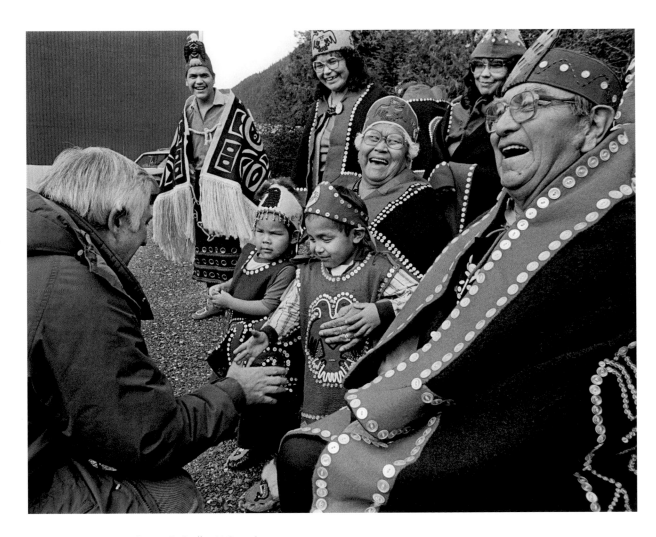

Orson Swindle, U.S. assistant
secretary of commerce, and
Shields family in Saxman.
October 8, 1986.

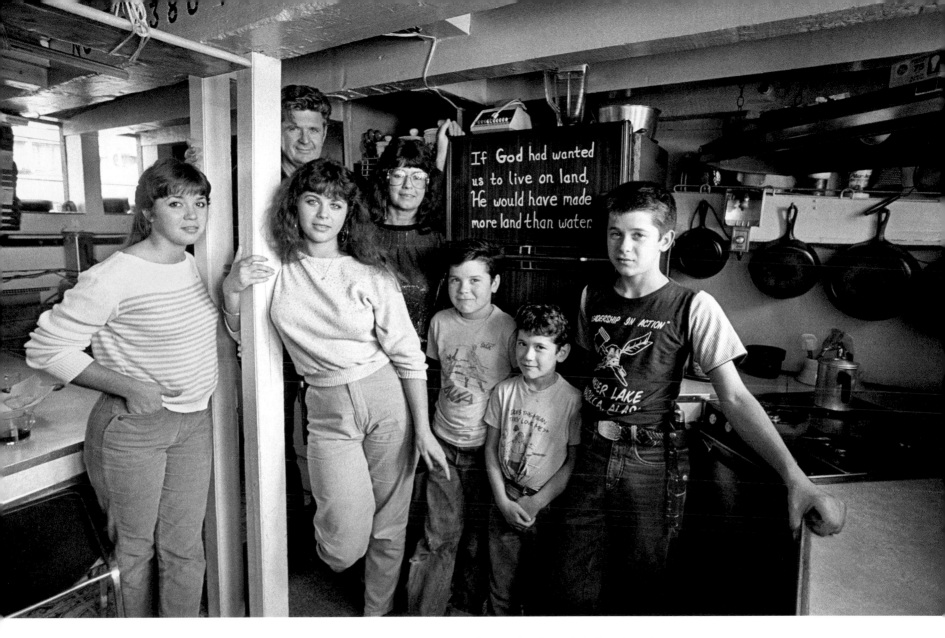

Bunton family on their live-aboard,
EZVZ, Bar Harbor.
September 25, 1986.

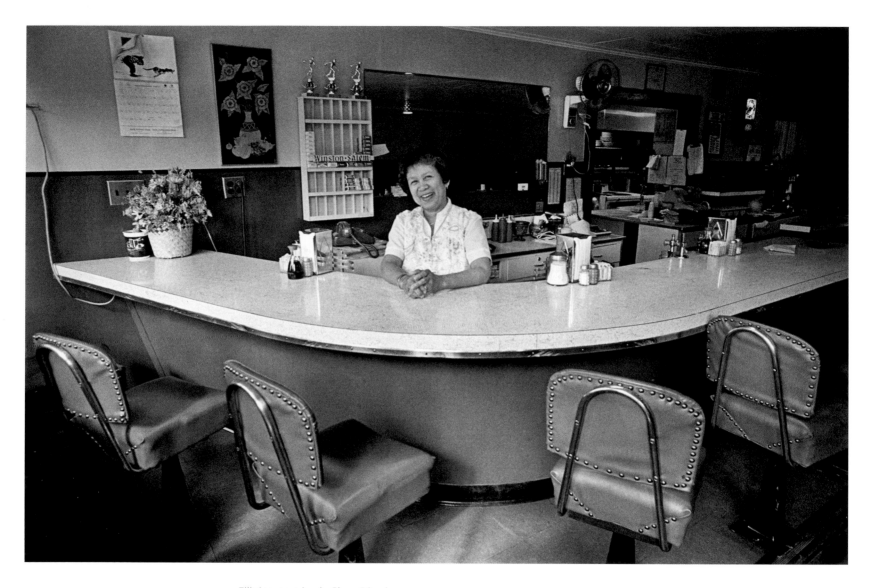

Filipina matriarch Clara Diaz in
Diaz Café. September 15, 1987.

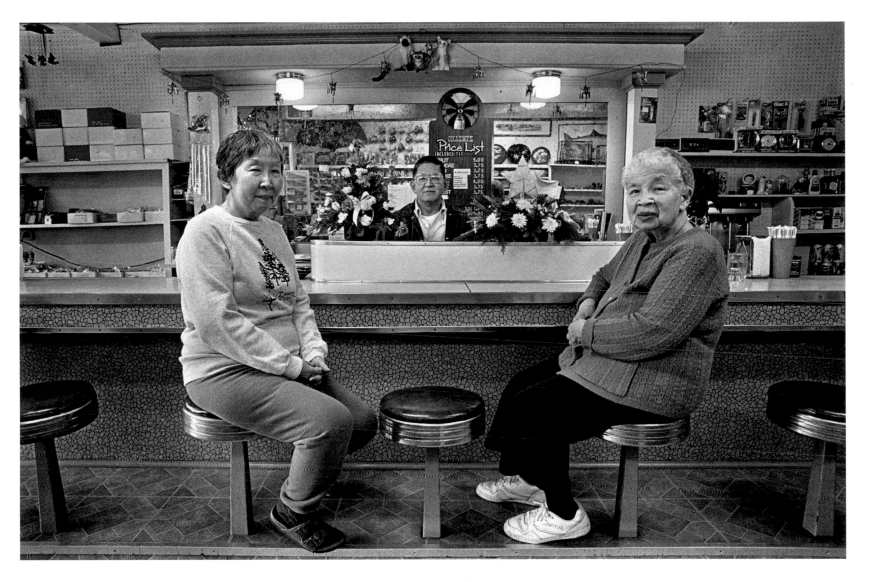

Ohashi family, Ohashi's.
December 16, 1994.

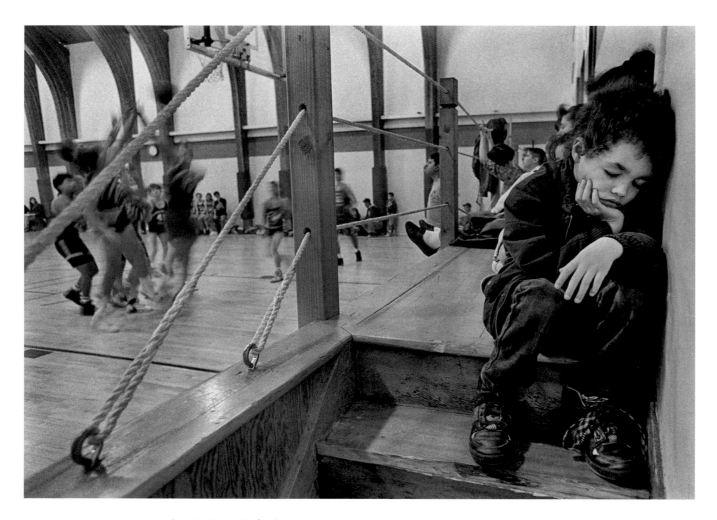

John Martin waits for his
father's game to end,
U.S. Coast Guard gym.
December 6, 1991.

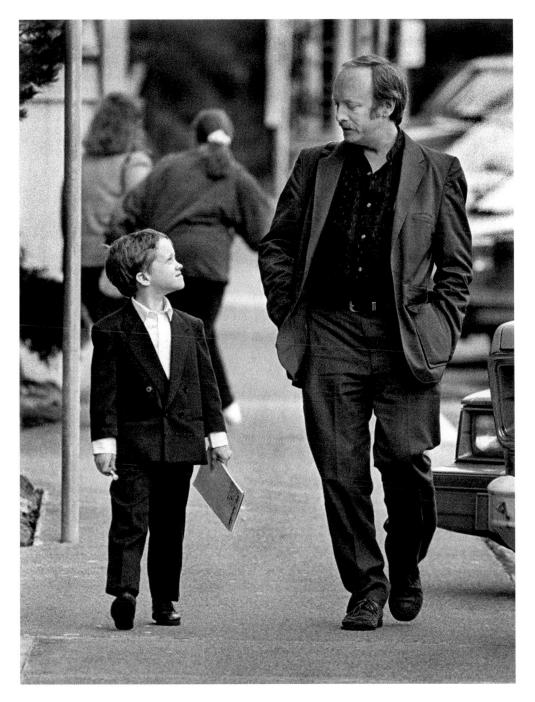

A work day with dad,
Jay and Tom Miller.
March 19, 1991.

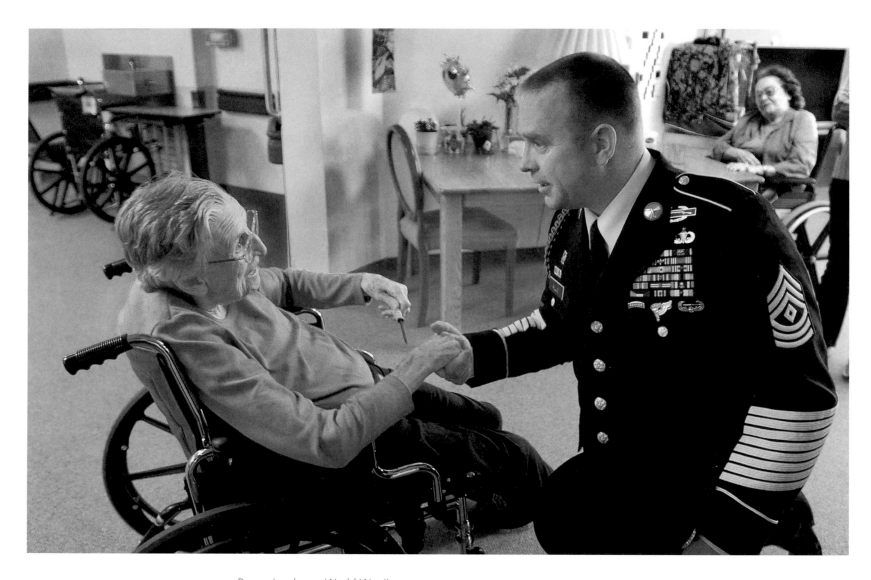

Peggy Jacobson, World War II nurse,
and Tod Willis, veteran, at the
Ketchikan Pioneer's Home.
May 29, 2006.

Deermount Street fire. July 8, 1985.

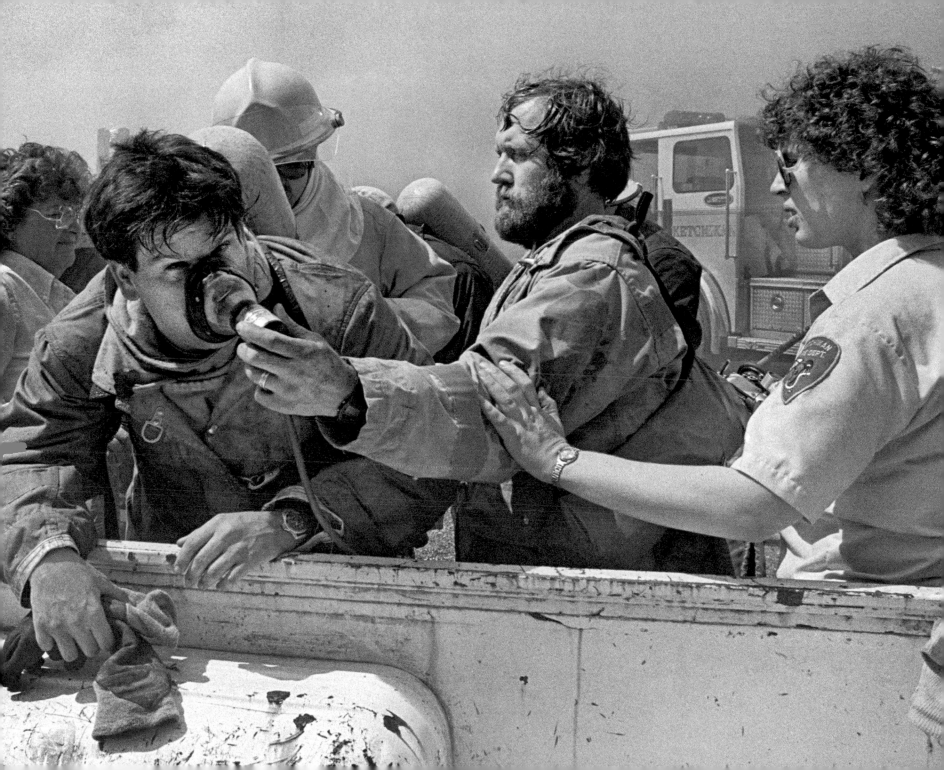

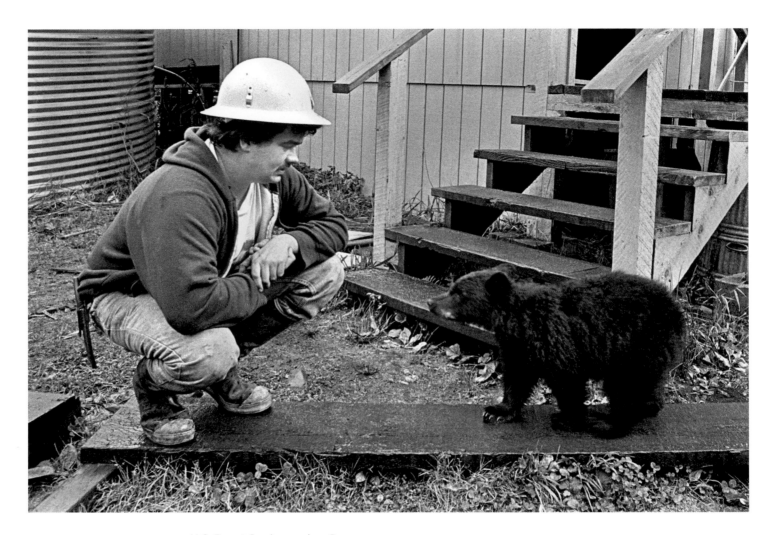

U.S. Forest Service worker Greg
Whaley with orphaned bear cub,
Spooky, at Traitor's Cove, Cleveland
Peninsula. October 12, 1989.

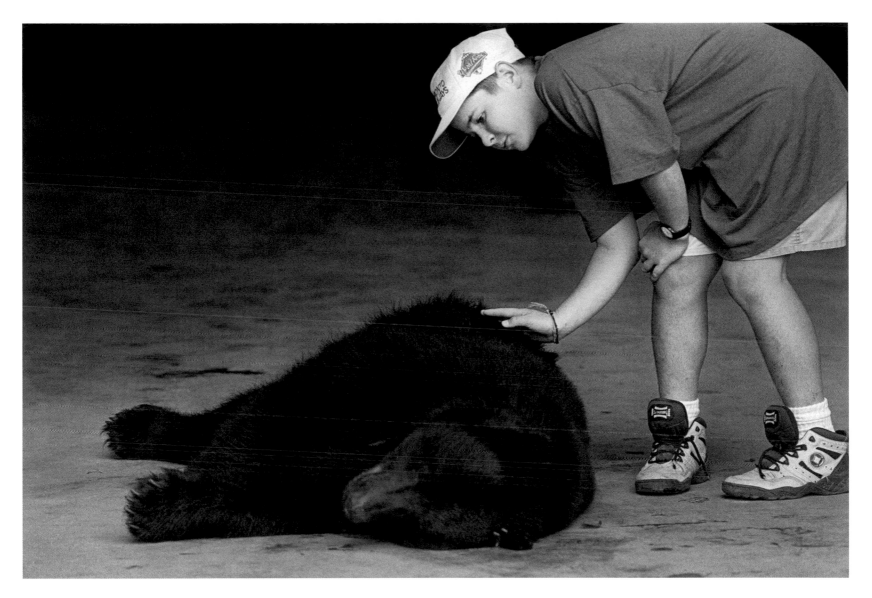

Tranquilized bear, Ketchikan landfill.
July 11, 1995.

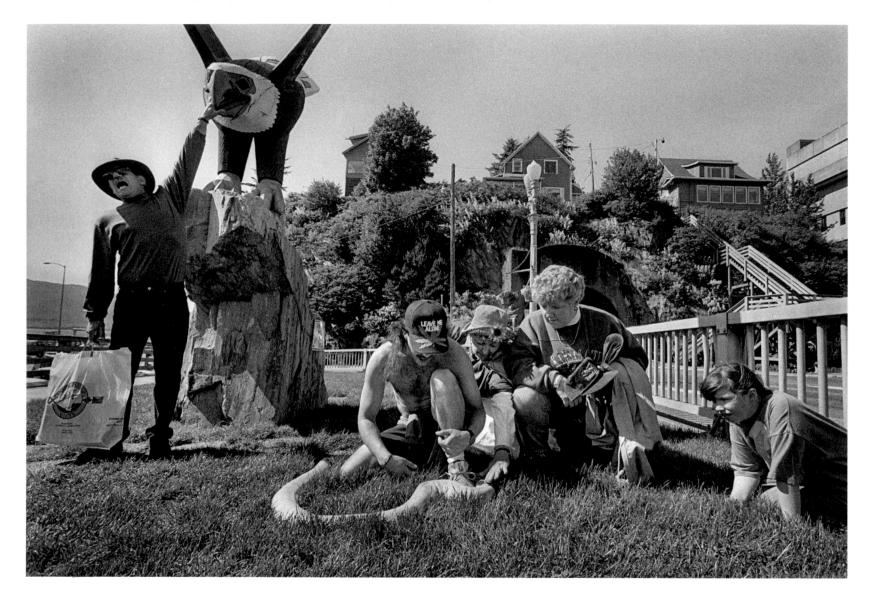

Downtown park, Thundering Wings
totem. June 20, 1996.

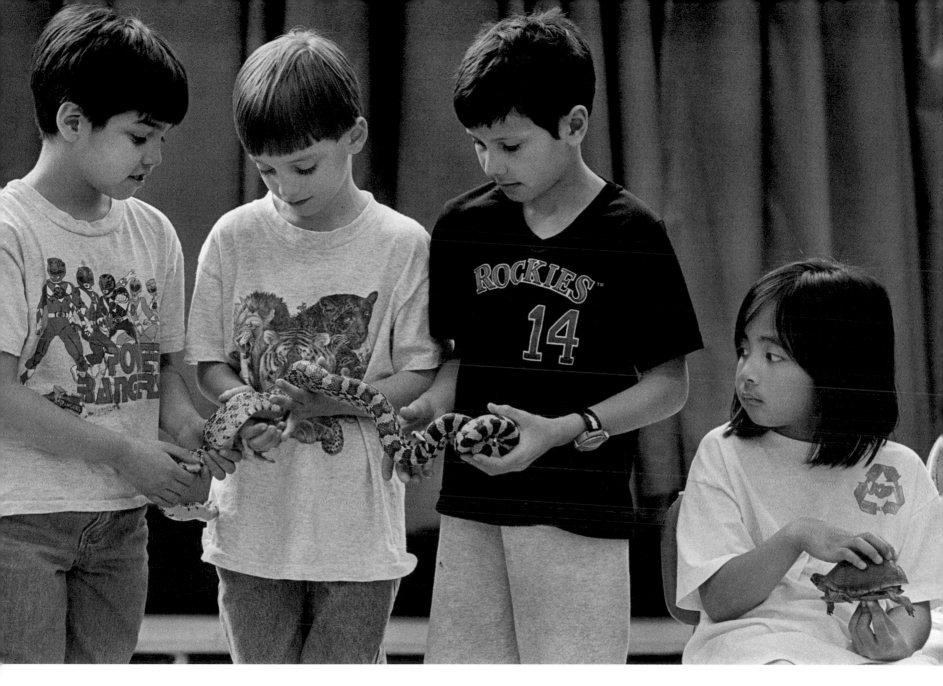

Snake study, Houghtaling school.
March 25, 1996.

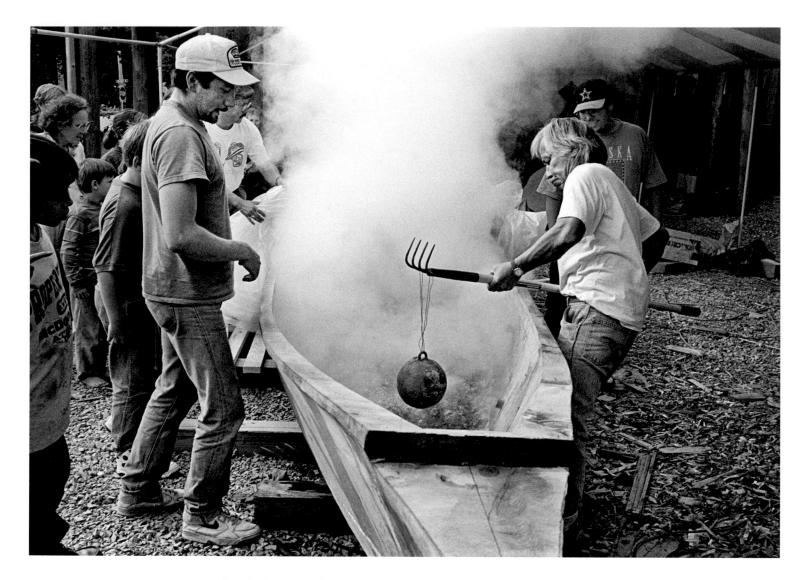

Nathan Jackson steaming canoe,
Saxman. August 19, 1995.

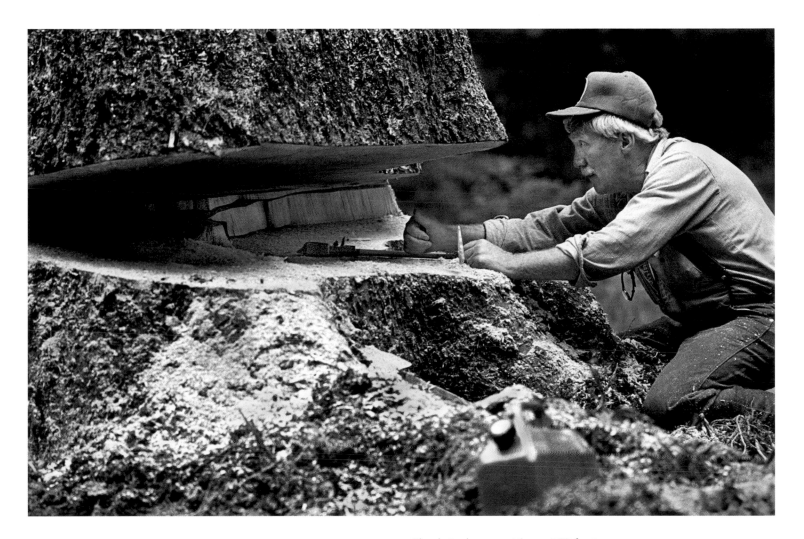

Chuck Anderson cutting a 160-foot
spruce for a Hawaiian canoe, Soda Bay.
May 29, 1990.

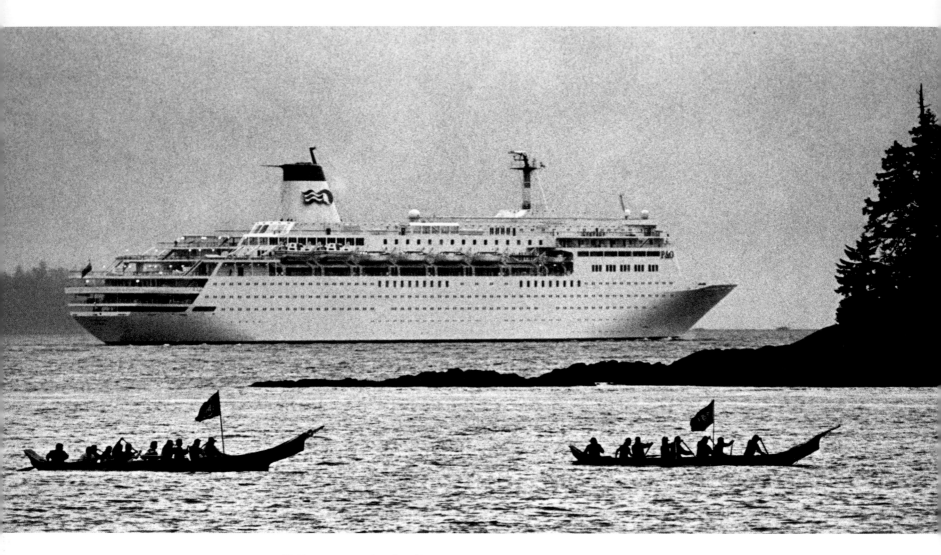

Haida canoes and cruise ship
Sky Princess. July 29, 1993.

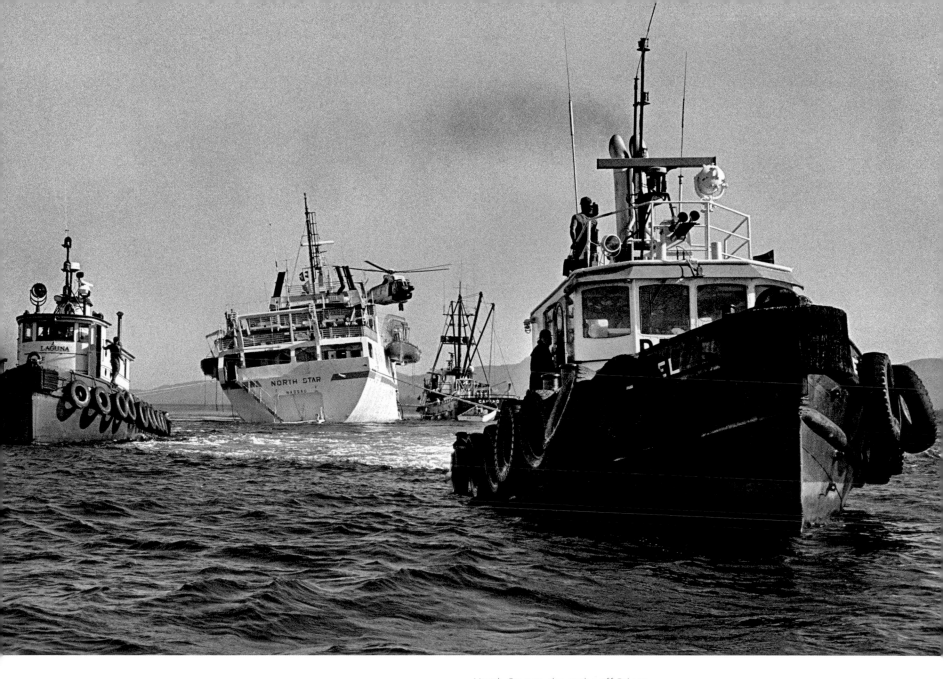

North Star on the rocks off Prince
of Wales Island. August 8, 1986.

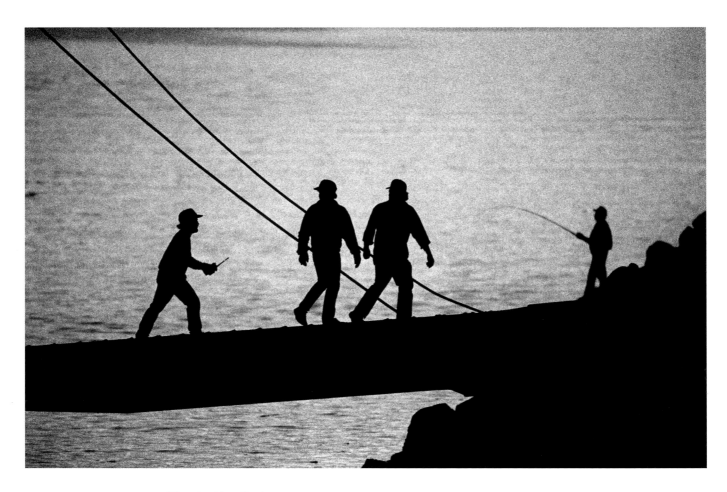

Disembarking the barge.
May 5, 1990.

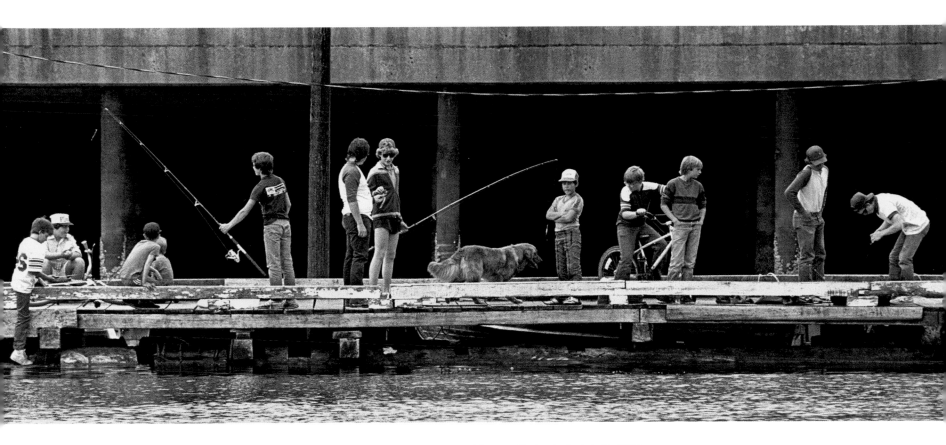

Thomas Basin dock. July 9, 1985.

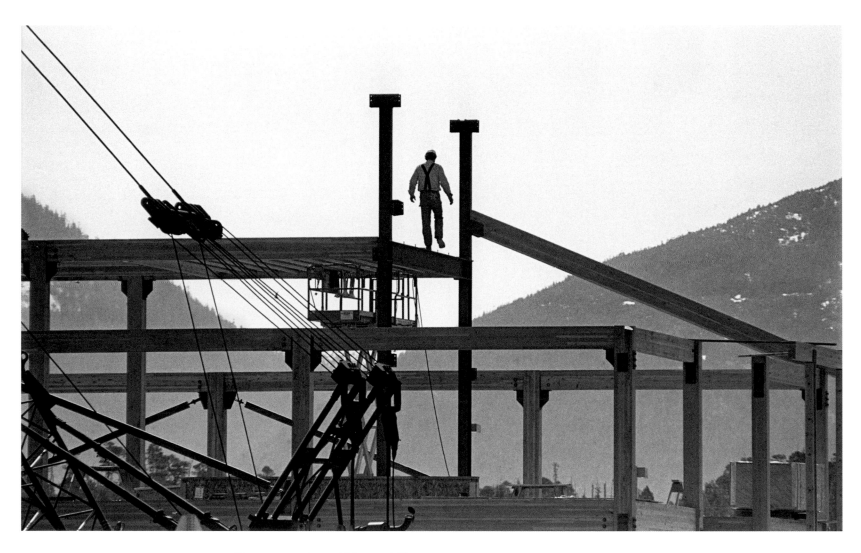

New construction, old Spruce Mill
dock site. April 10, 1997.

Spruce Mill Bridge, since removed.
January 5, 1988.

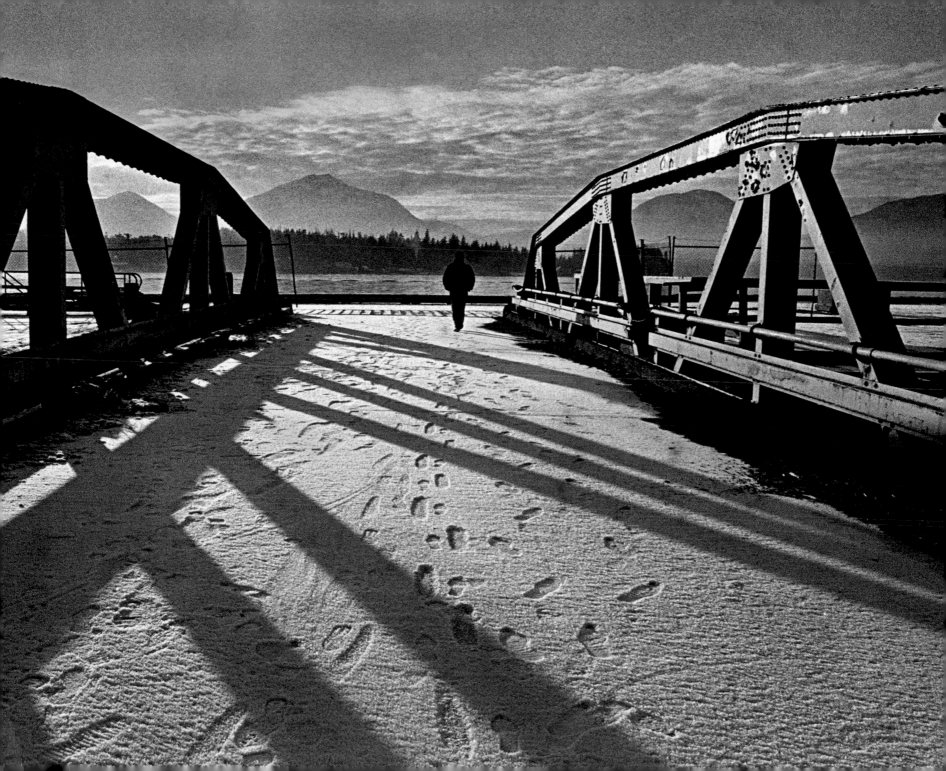

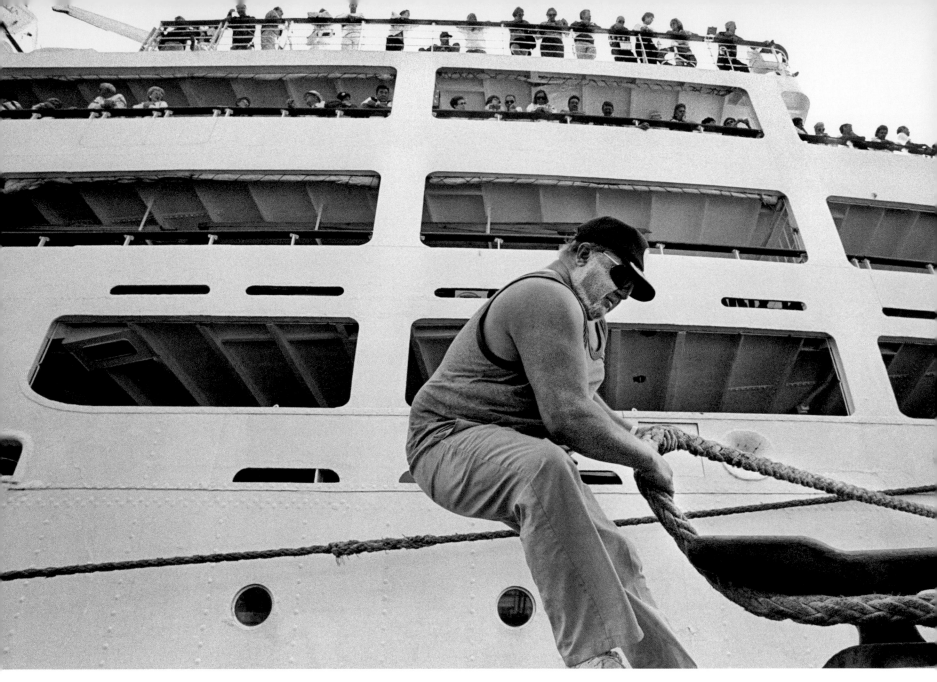

Untying *Dawn Princess*. July 23, 1990.

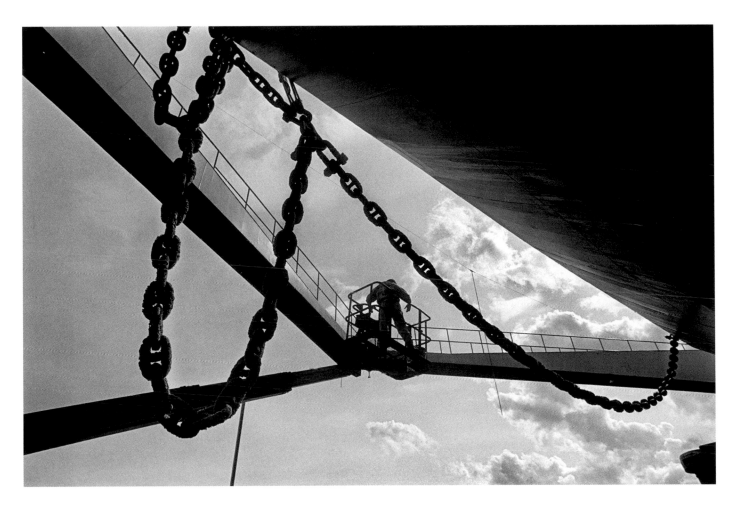

Ketchikan Shipyard, barge *Harry
Merlo*. August 8, 1997.

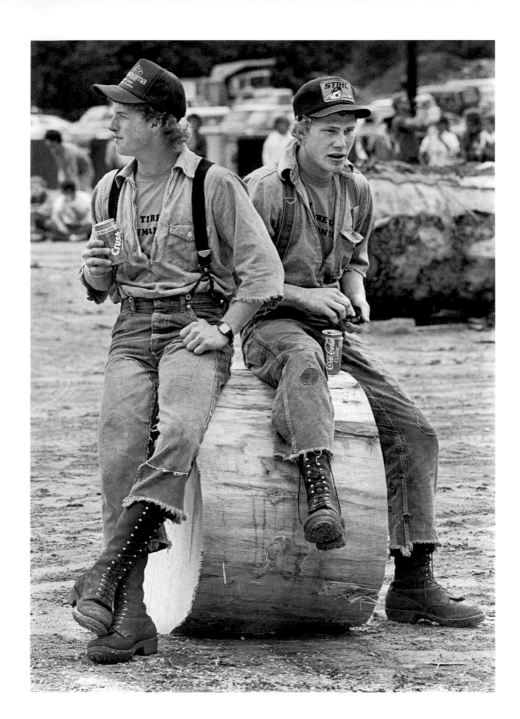

Loggers Rodeo.
Fourth of Julyw, 1986.

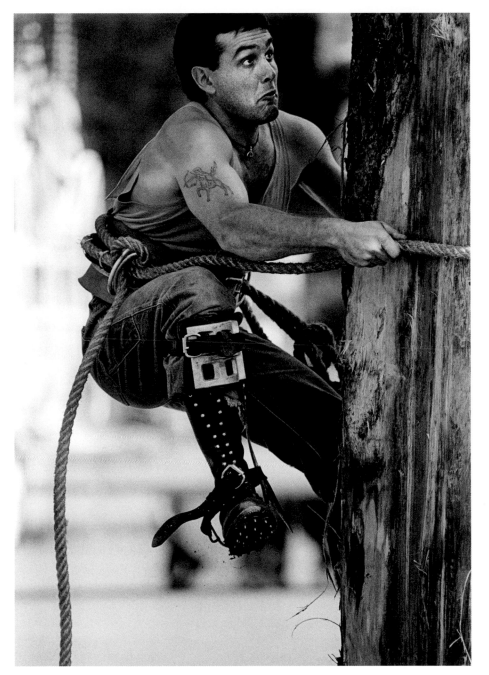

Loggers Rodeo, speed climb.
Fourth of July, 1992.

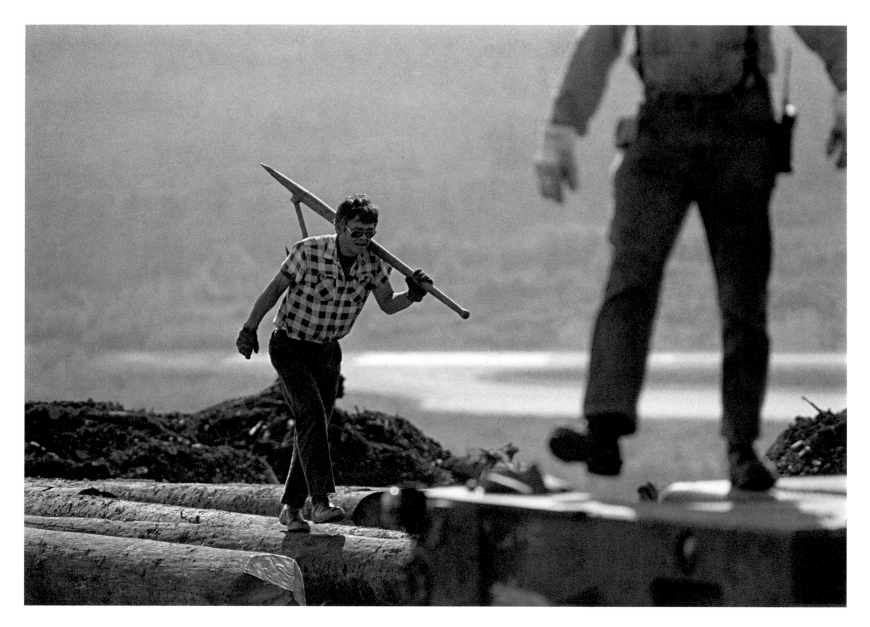

Man with Peavey, log-walking.
September 5, 1996.

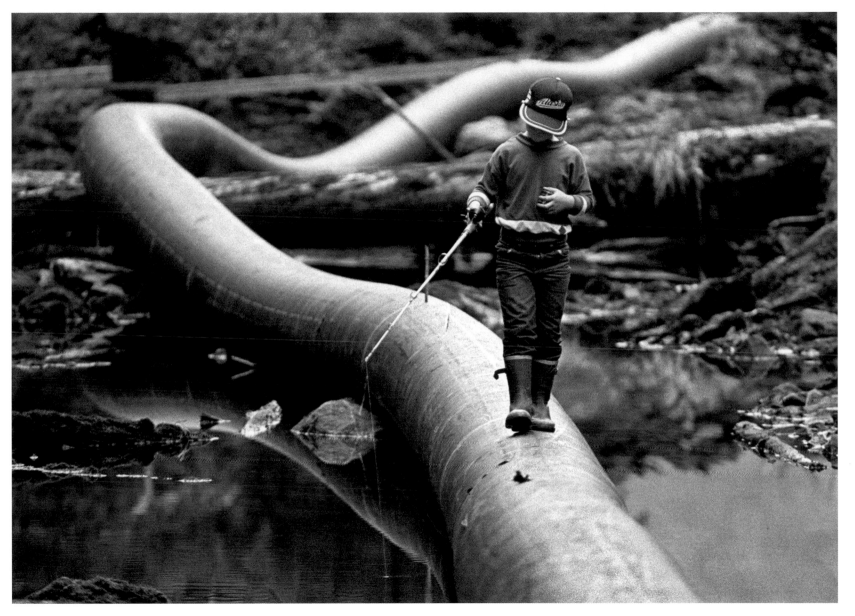

Pulp Mill water pipeline,
Perseverance Creek.
September 27, 1989.

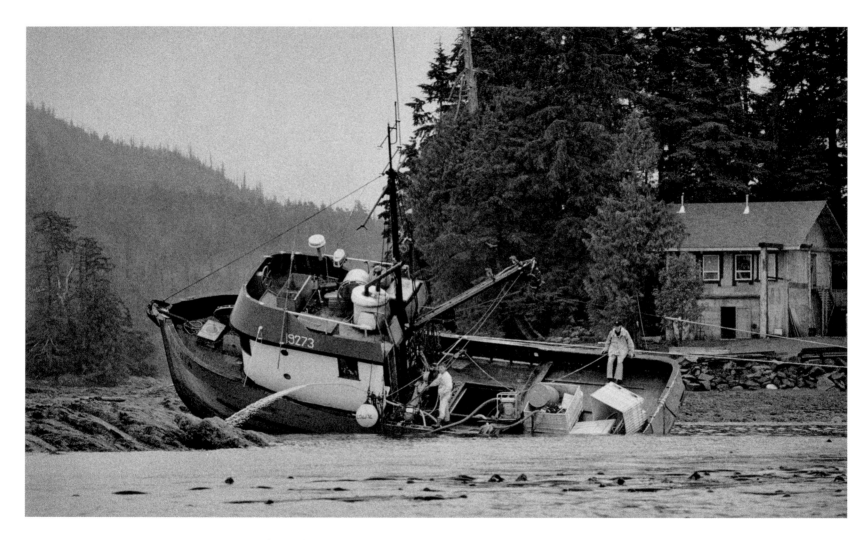

Seine boat *Claudia* aground,
Danger Island. August 9, 1996.

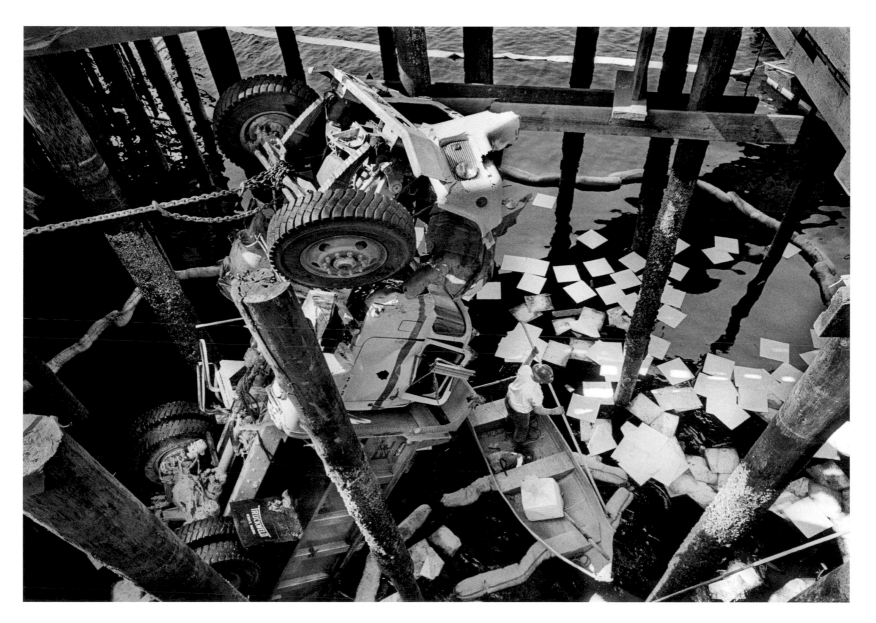

Heavy load, Ellis dock. May 18, 1992.

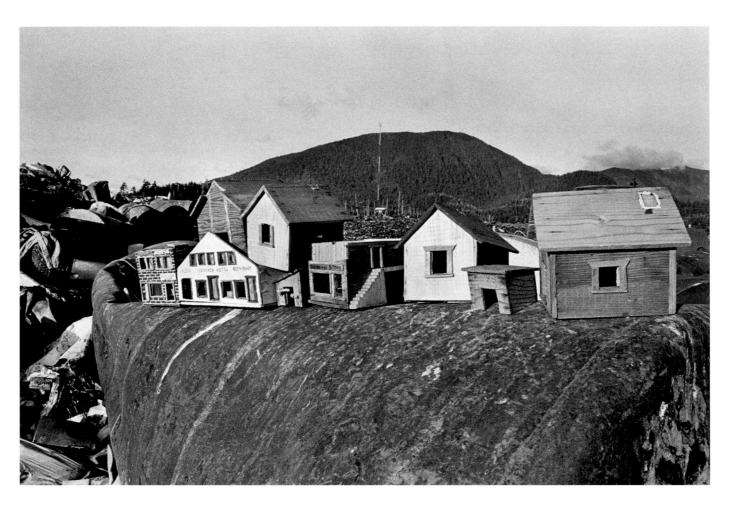

Abandoned cowboy town,
Ketchikan landfill.
November 9, 1993.

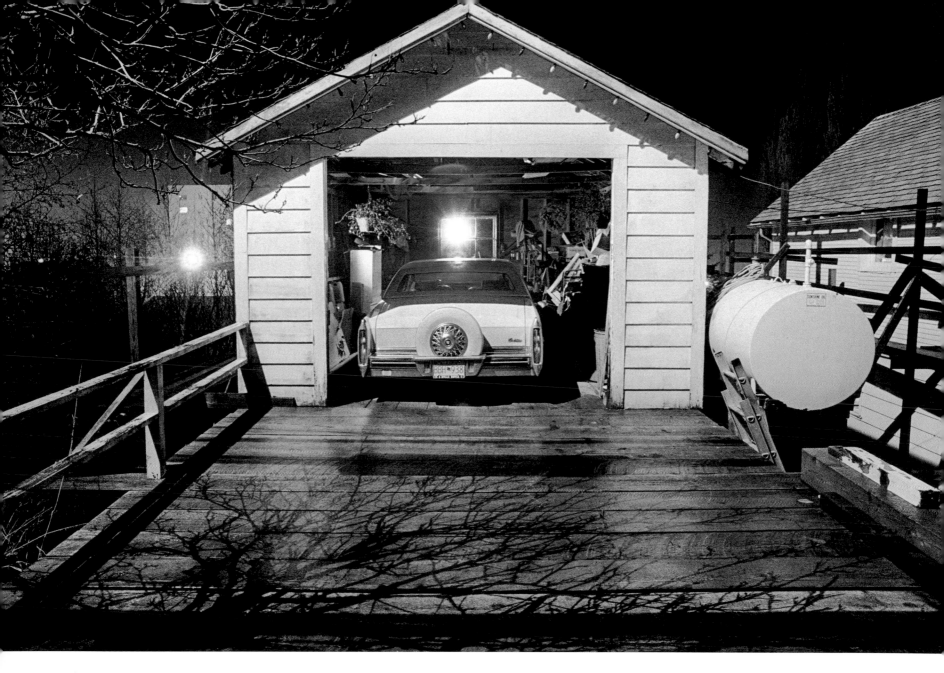

Cadillac garage, Second Avenue.
December 21, 1986.

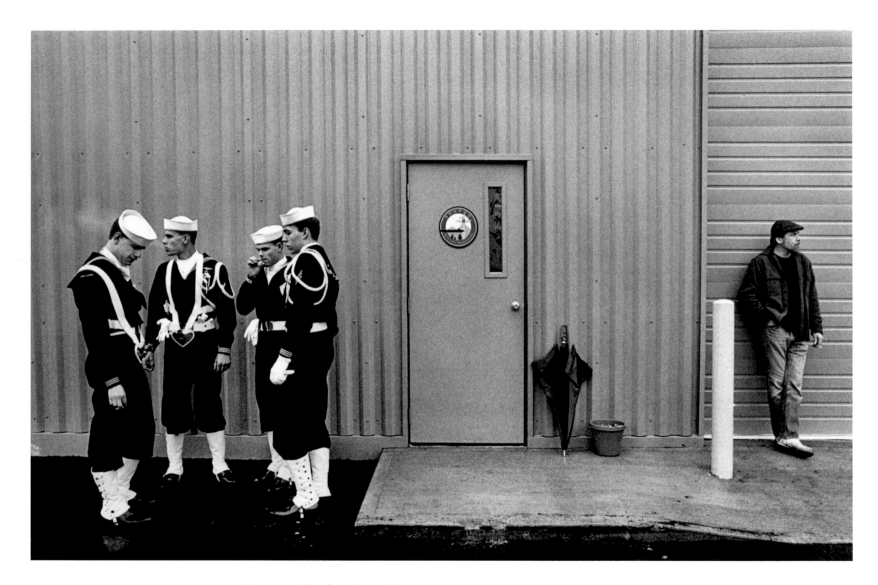

Navy acoustic submarine testing
station dedication, Back Island.
November 7, 2009.

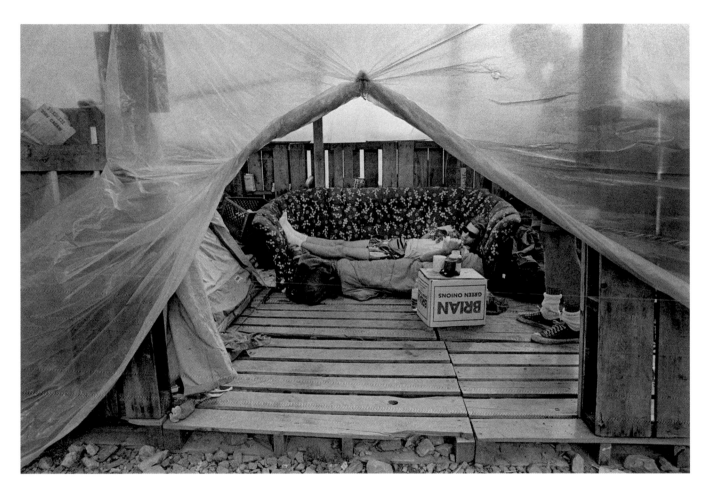

Blaine in his Tent City home.
September 5, 1990.

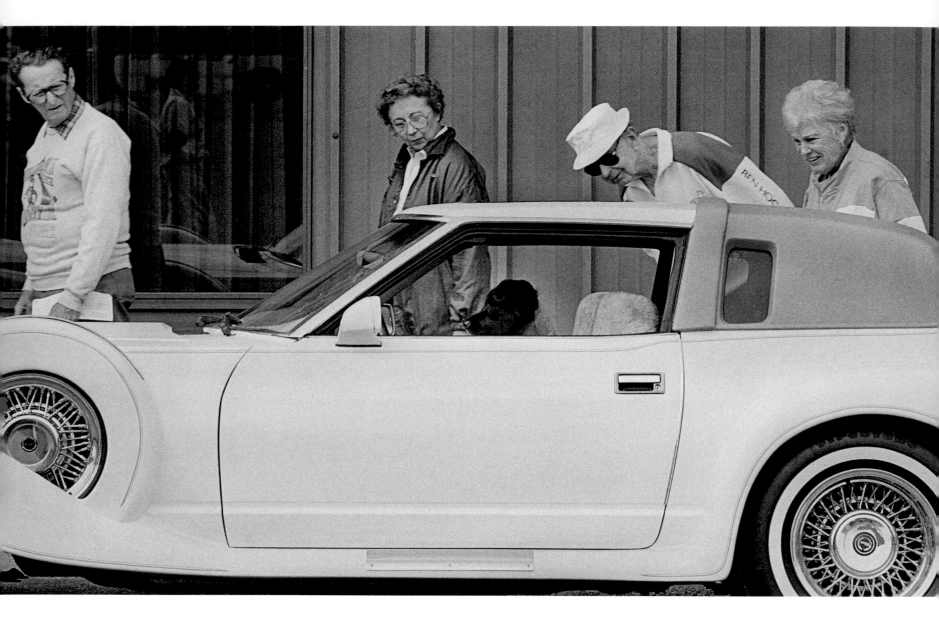

Tourists and canine driver. July 6, 1995.

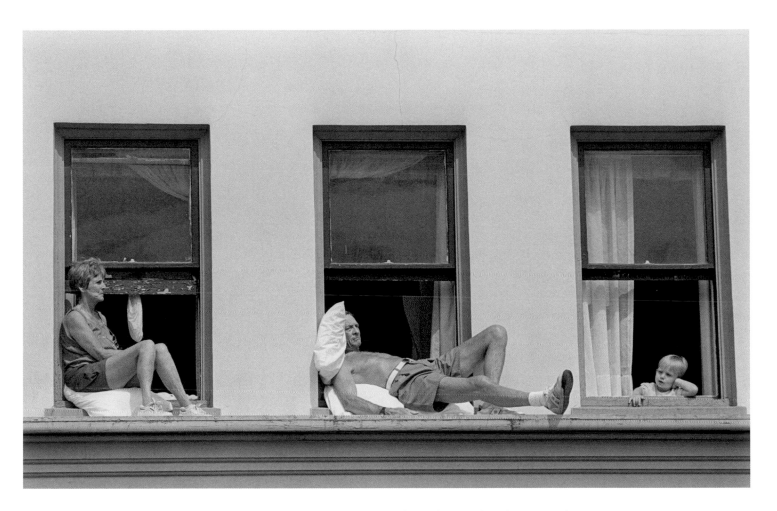

Above the parade, Gilmore Hotel.
Fourth of July, 1997.

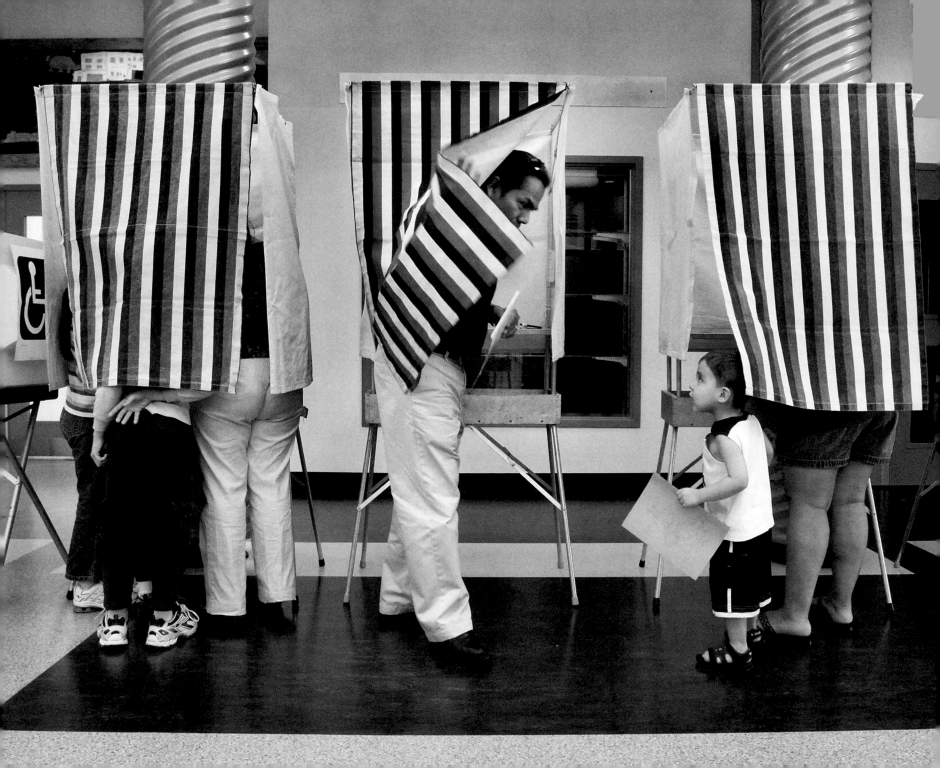

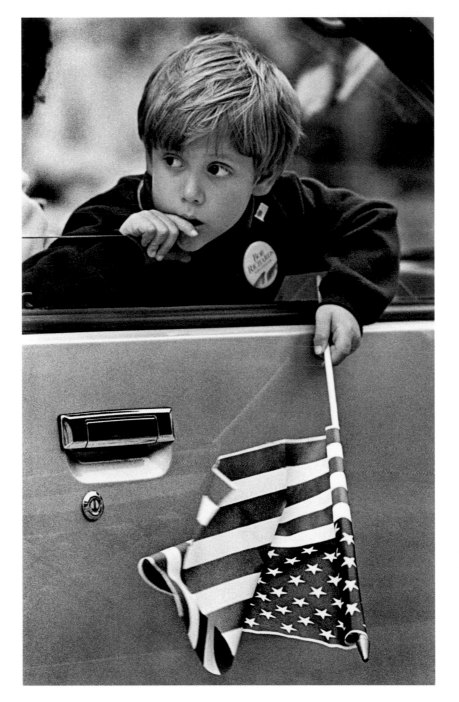

Boy with flag, Fourth of July parade. 1986.

Election Day, Fawn Mountain School. August 22, 2006.

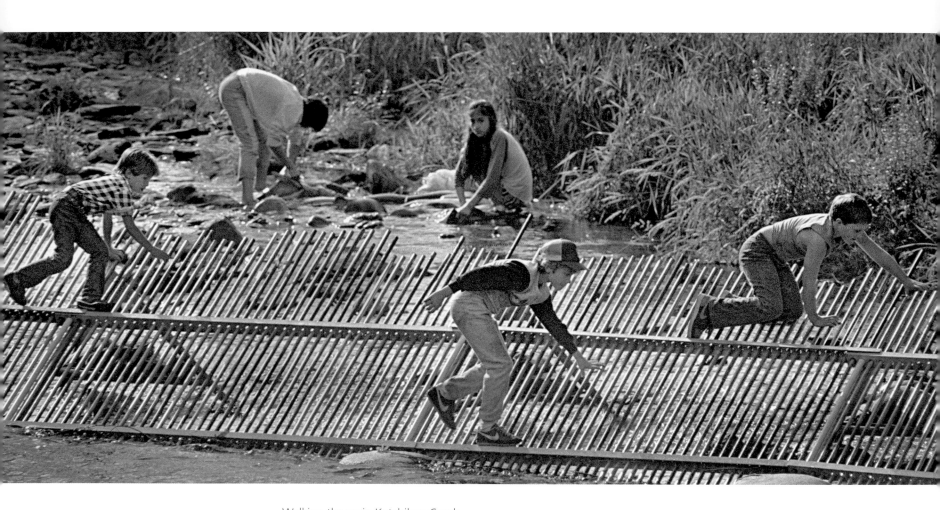

Walking the weir, Ketchikan Creek.
August 25, 1986.

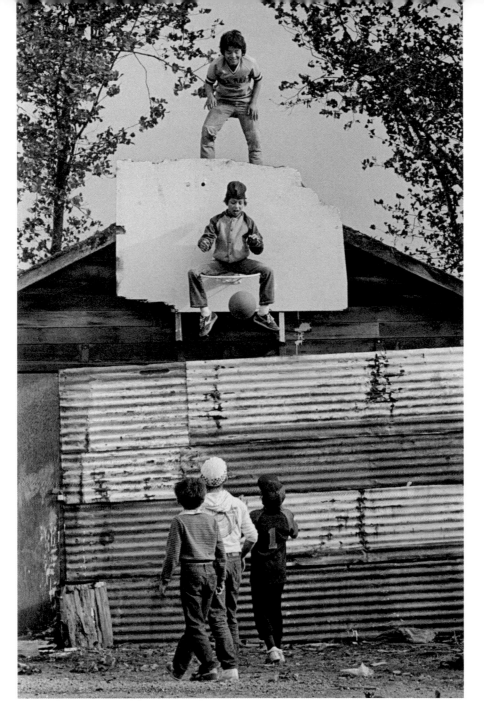

Outdoor basketball. June 2, 1985.

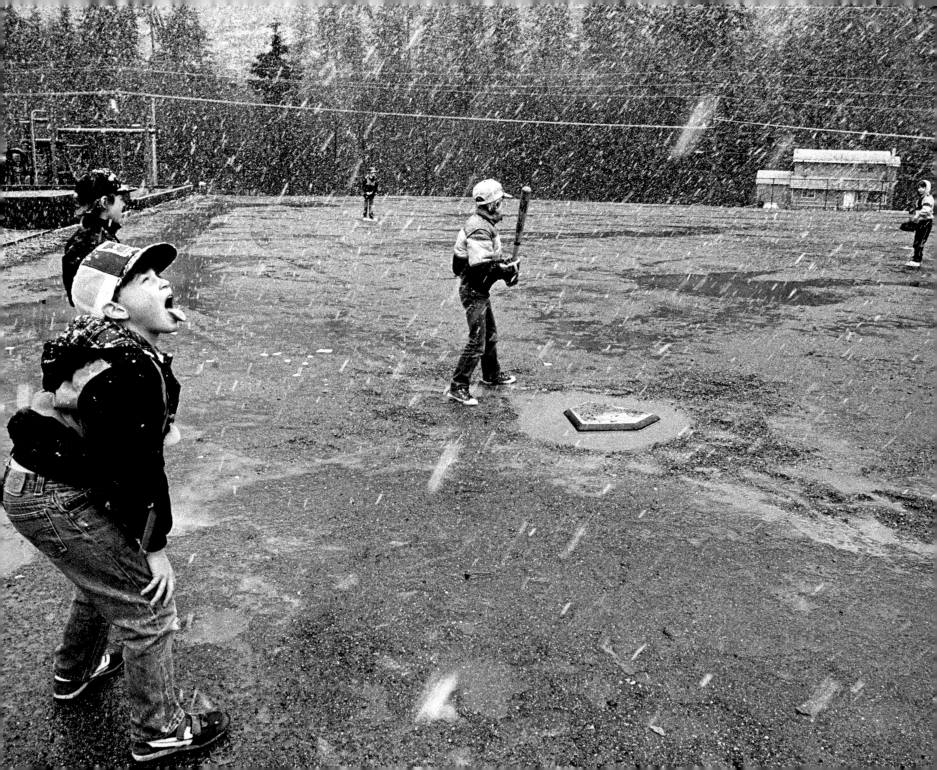

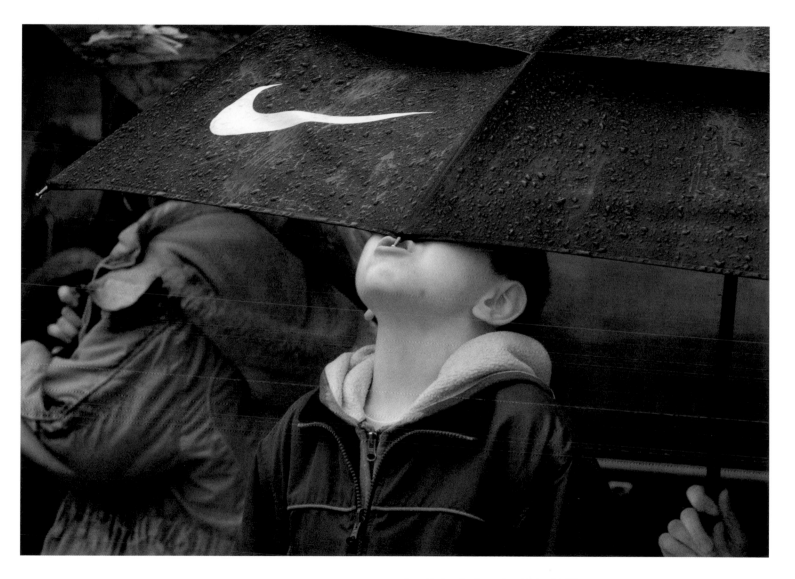

Just Doing It. Fourth of July, 2007.

Boys of summer. April 19, 1985.

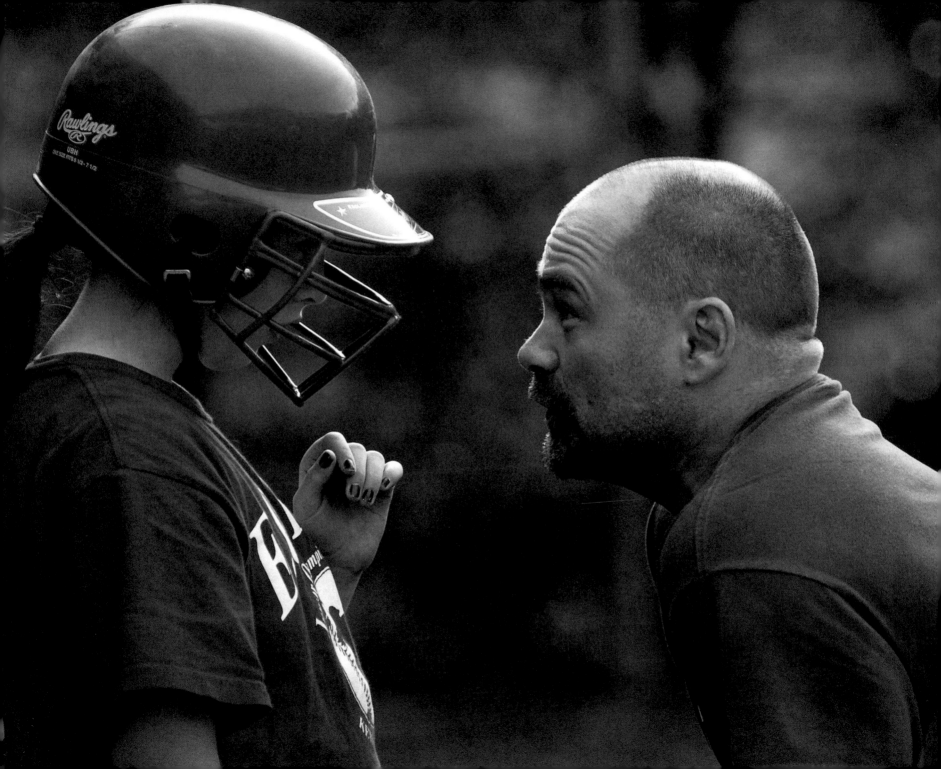

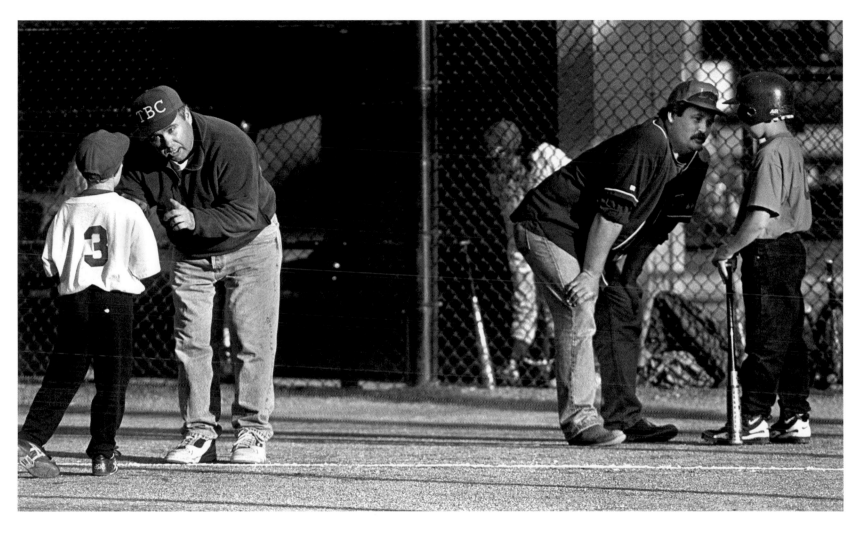

Little League Baseball. July 1, 1996.

Pep Talk. July 14, 2006.

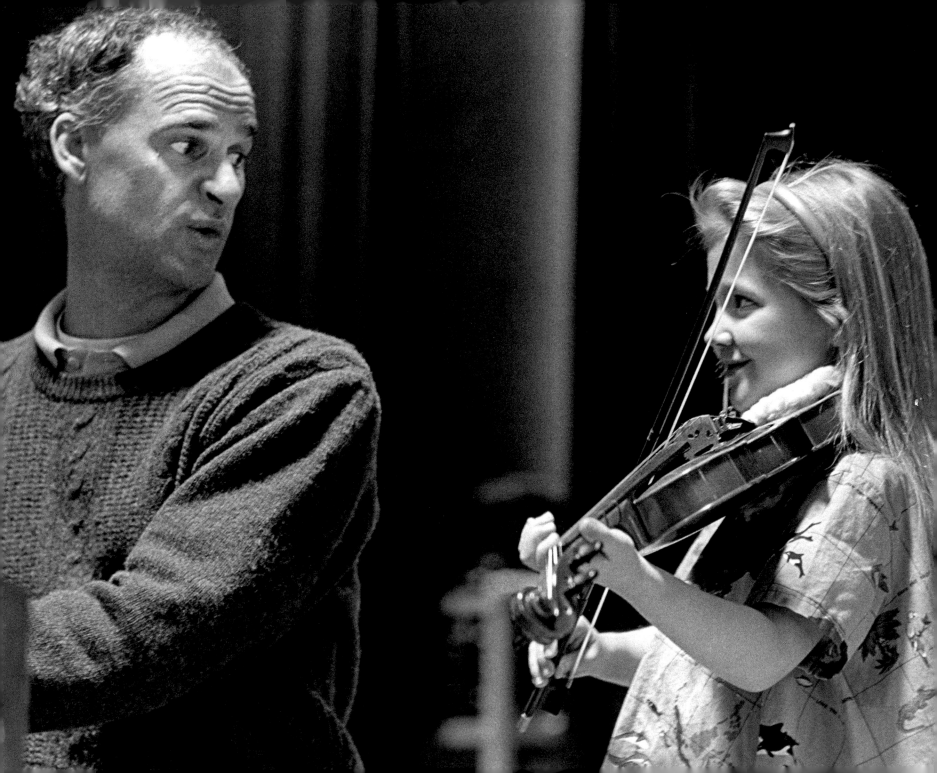

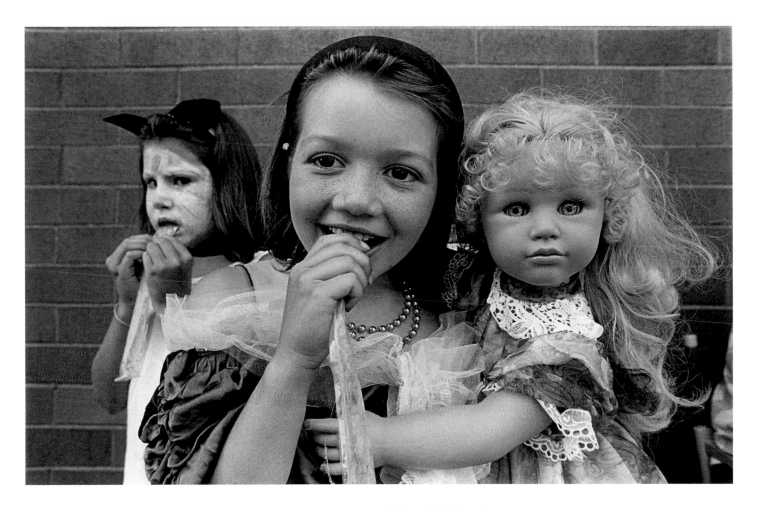

Pet and Doll Parade.
August 12, 1994.

First recital for Hannah Martin,
with teacher Greg Morelli.
February 23, 1994.

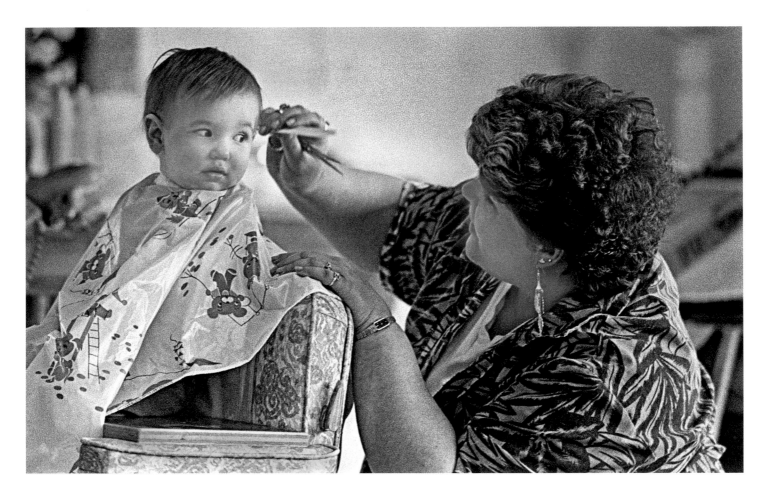

First haircut. September 19, 1986.

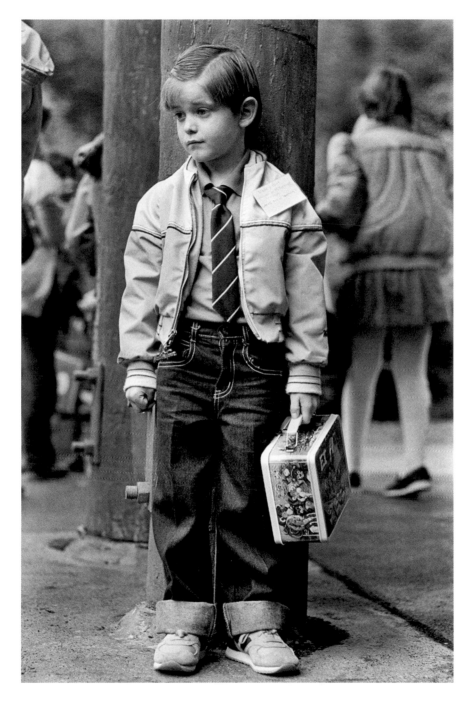

First day of school.
August 30, 1984.

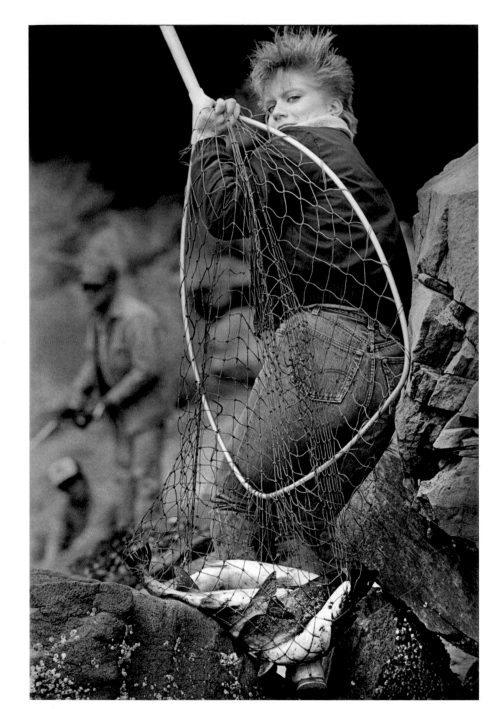

Fish haul at Mountain Point.
July 28, 1986.

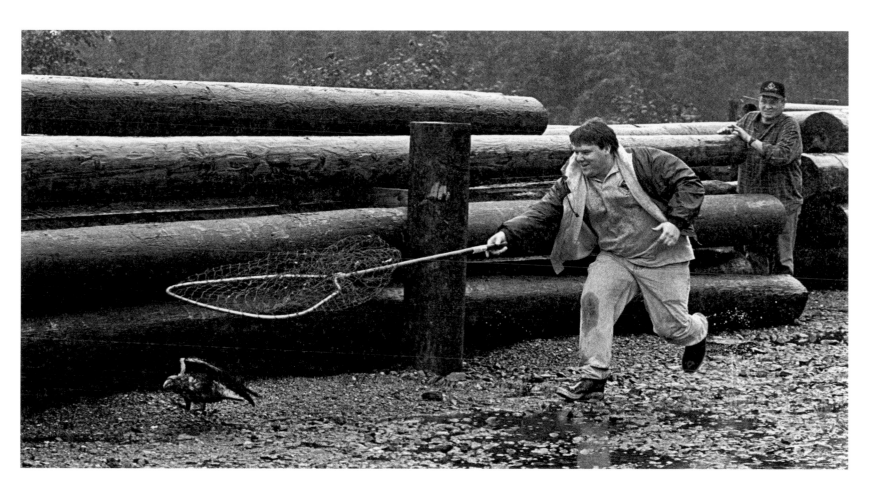

Injured raven at Eichner and Eichner.
July 27, 2000.

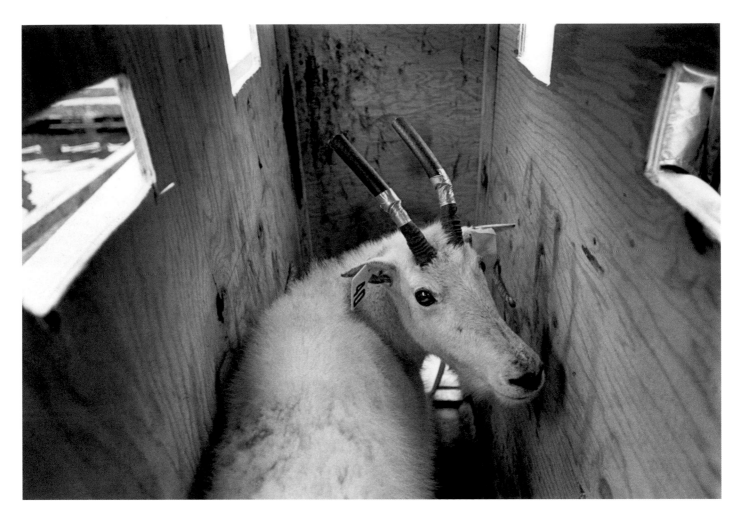

Goat transplant. August 12, 1986.

Abandoned bear cub.
March 19, 1991.

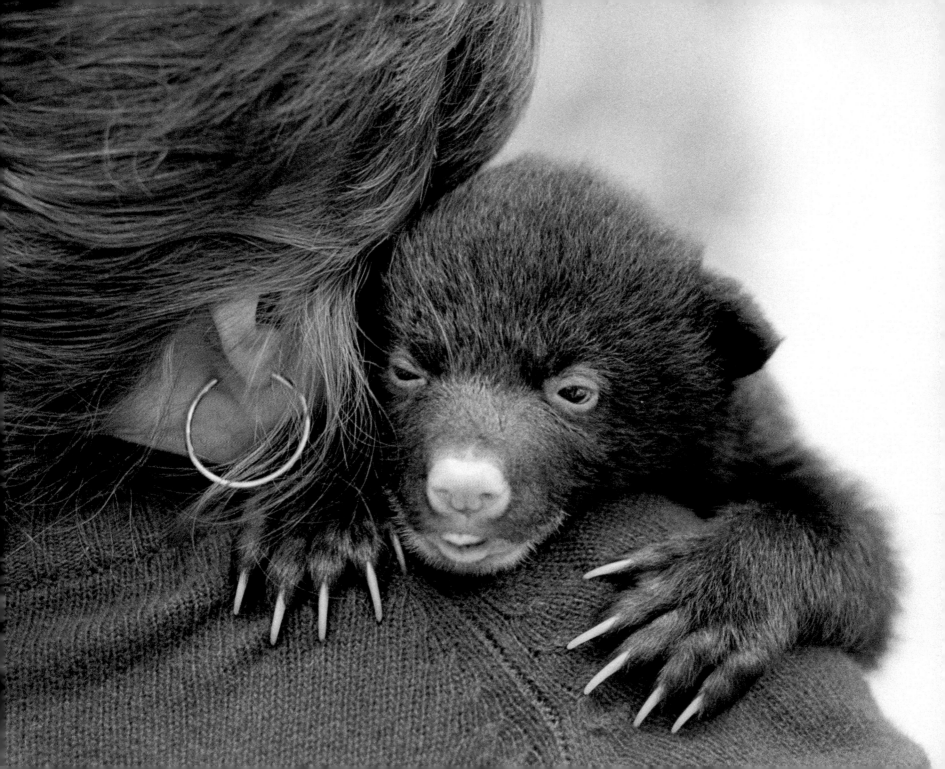

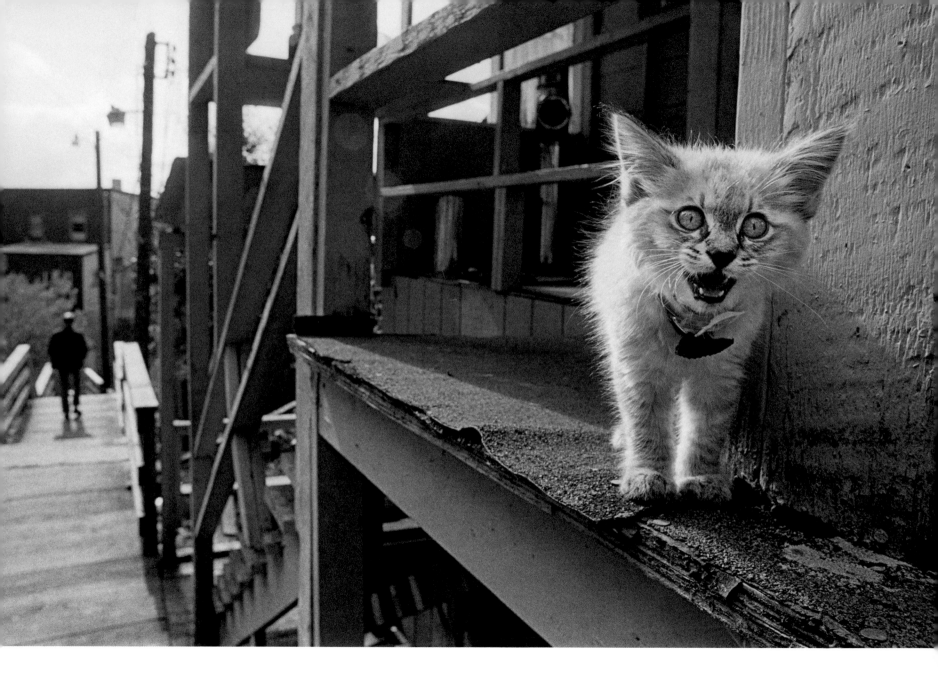

Bucey Way cat.
September 15, 1987.

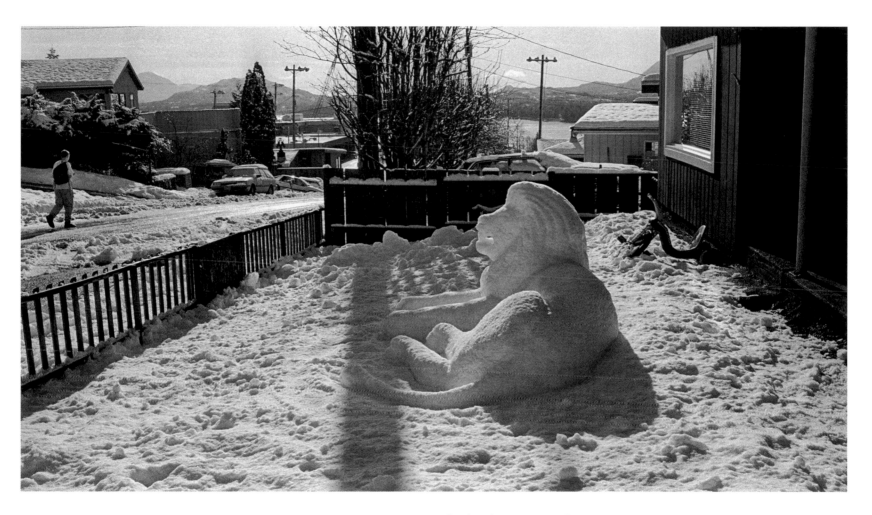

Lion in winter, Monroe Street.
February 16, 1994.

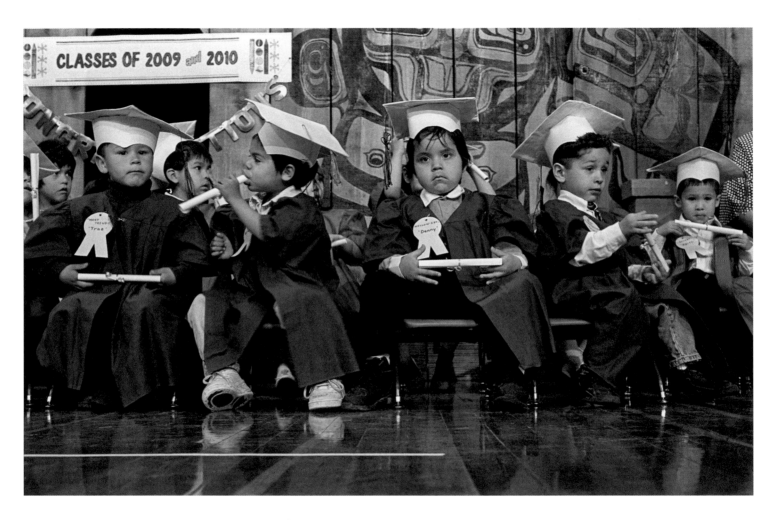

Head Start grads of 2009 and 2010
in Saxman. May 10, 1996.

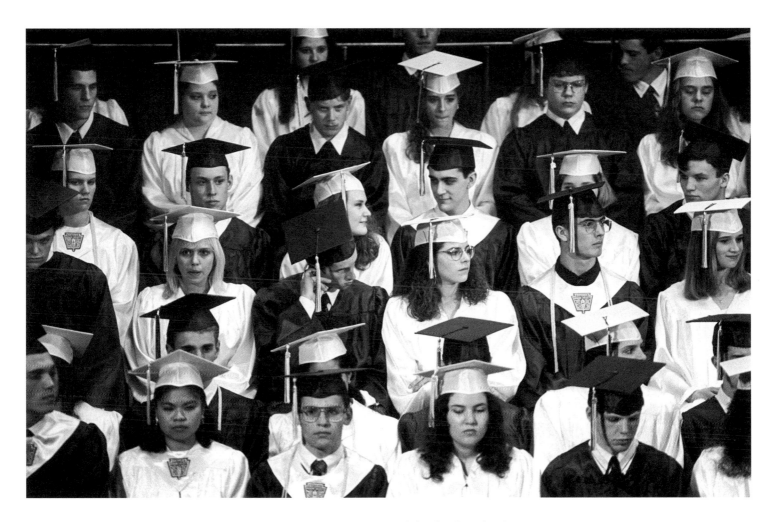

High school graduation.
May 23, 1993.

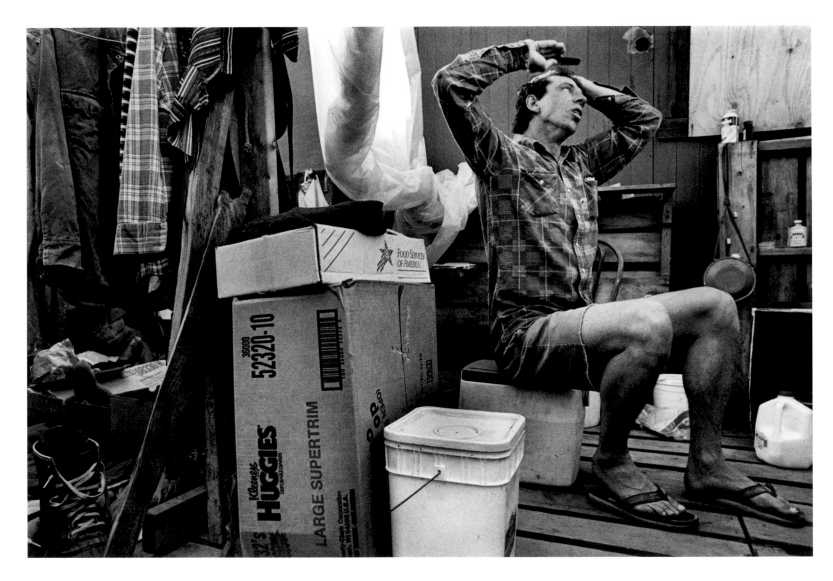

Wes Mathews, Tent City.
Summer 1990.

Kate Gill and Lance DeBoyle,
Tent City. September 15, 1990.

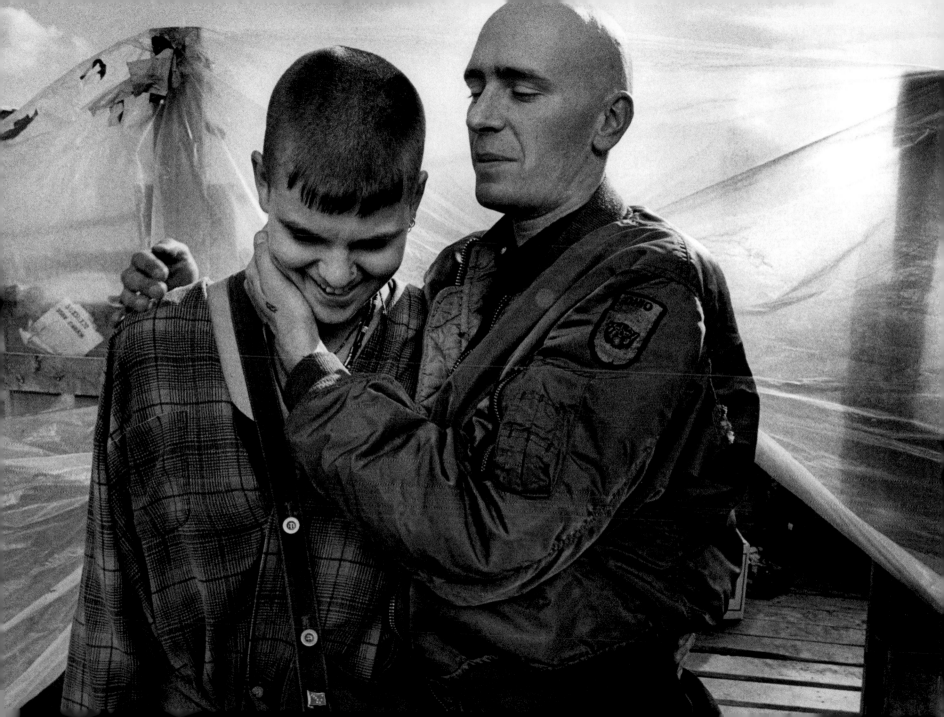

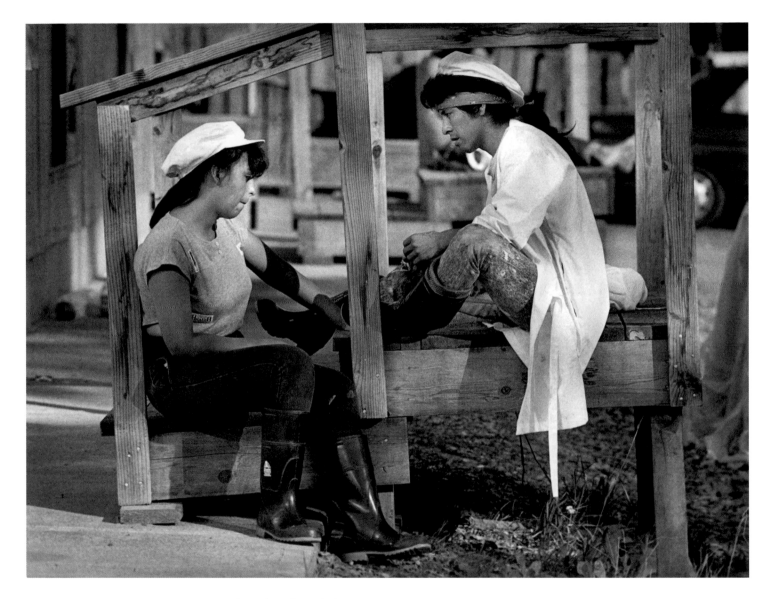

Rosa Maria and Paulino Cipriano,
Tent City. Summer 1990.

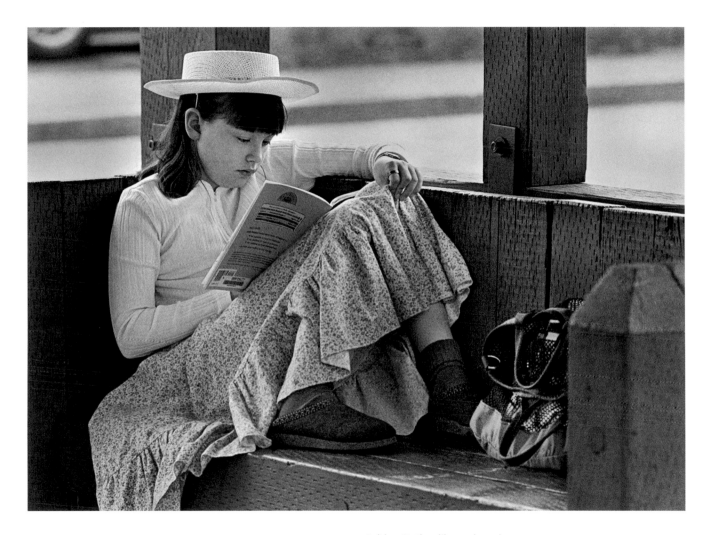

Ashley Butler, library bench.
June 11, 1997.

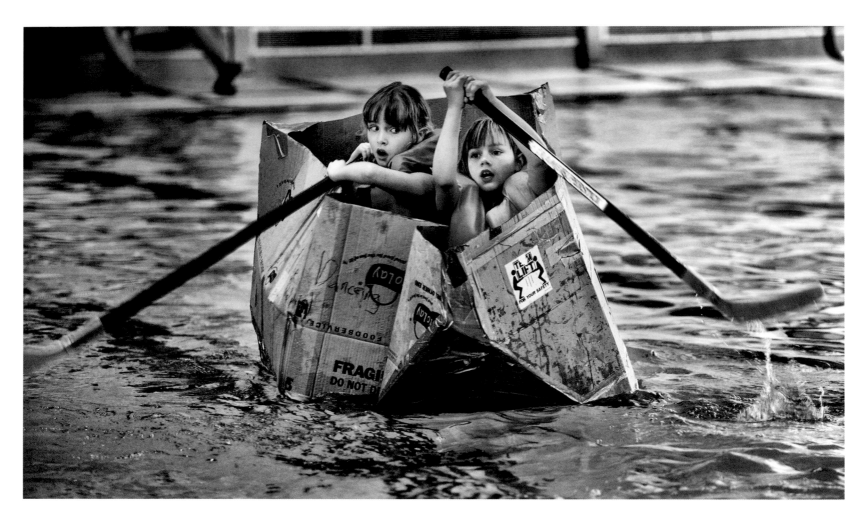

Boxes can float.
February 26, 2009.

New Sourdough Bar sign.
October 31, 2000.

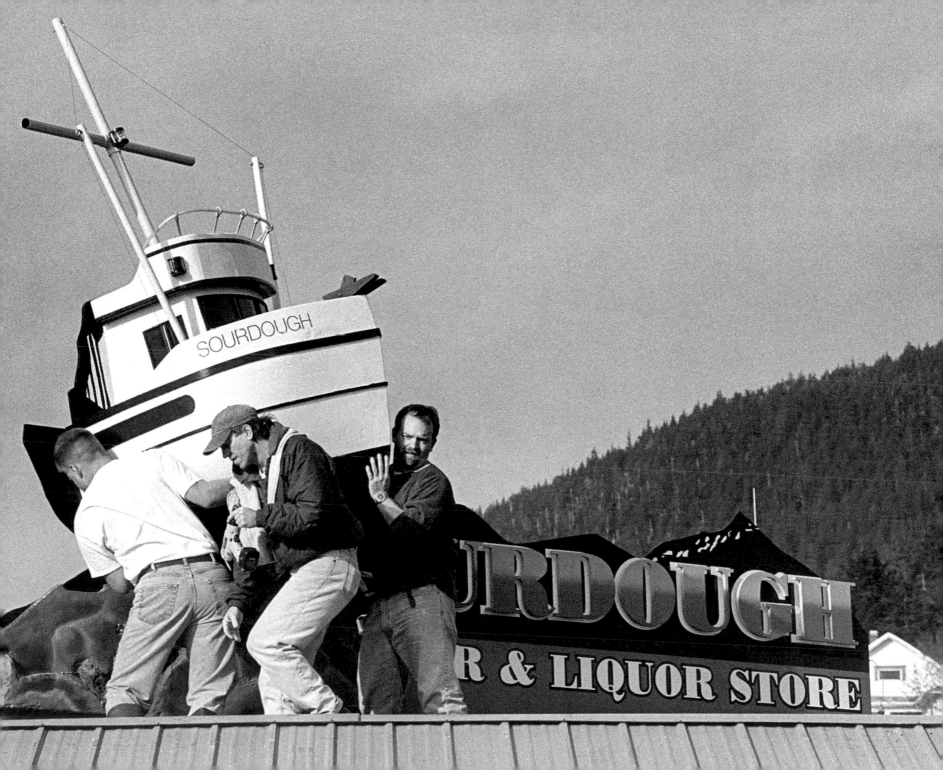

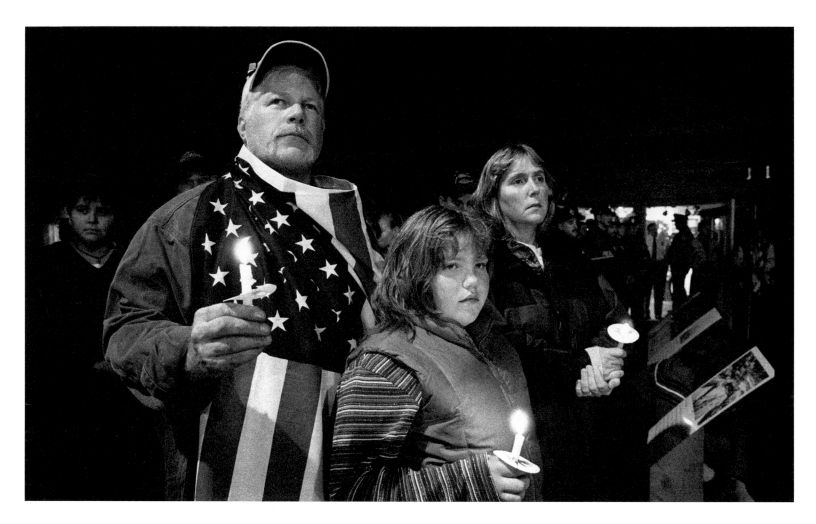

Patriotic rally. September 18, 2001.

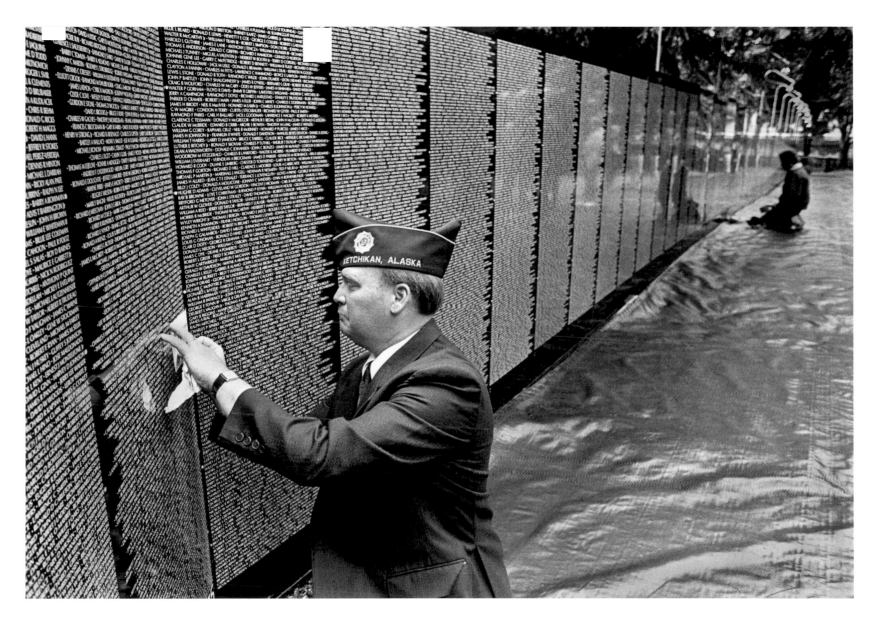

Remembering best friend on the
Moving Wall Vietnam War Memorial.
July 23, 1997.

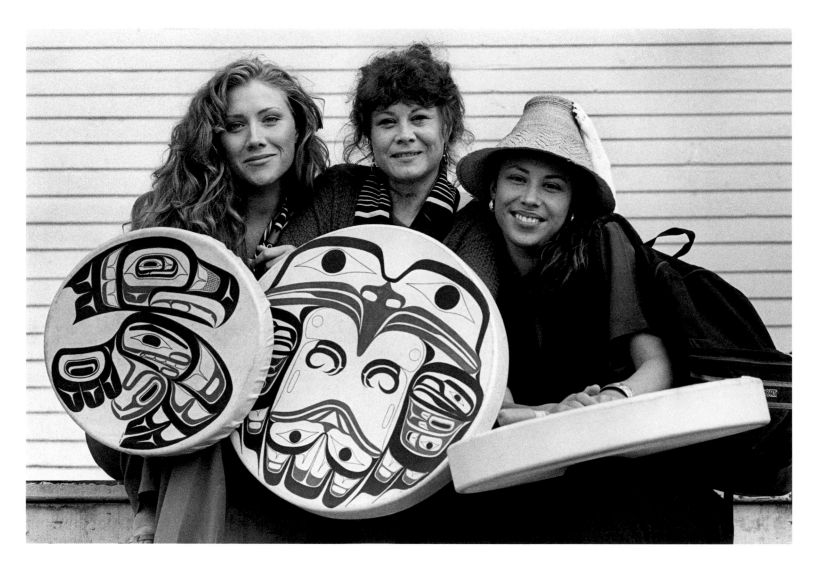

April Churchill, center, and daughters
Paula and Teresa, Metlakatla.
September 10, 1994.

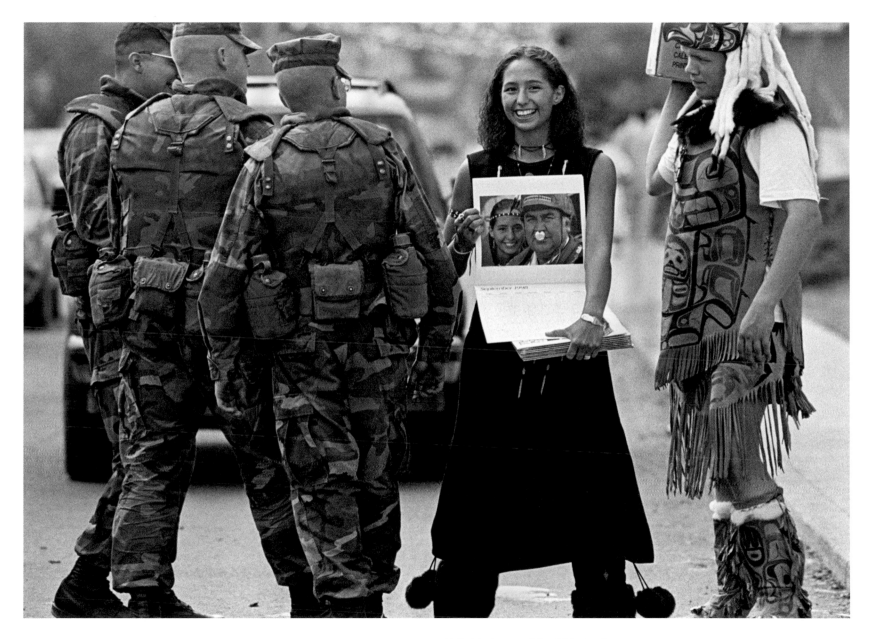

U.S. Marines and David R. Boxley
look at calendar with Miquel'l
Askren, Metlakatla. August 7, 1997.

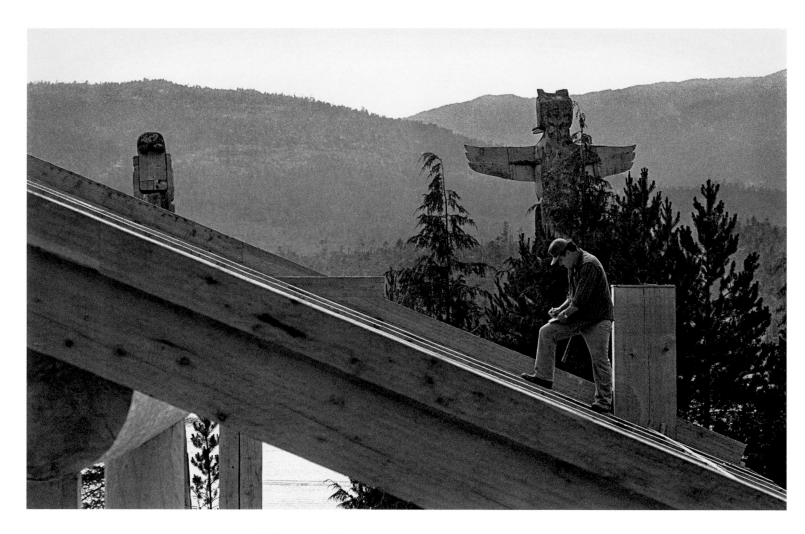

Saxman Tribal House under
construction. July 9, 1987.

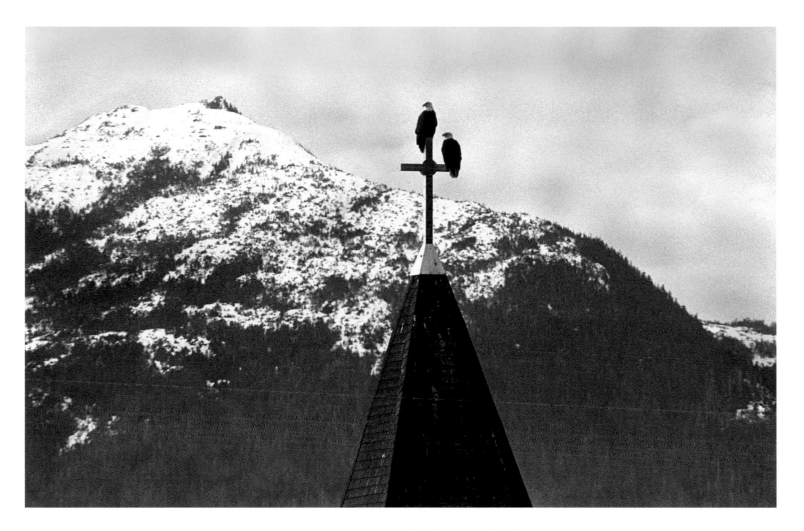

First Lutheran Church.
March 10, 2000.

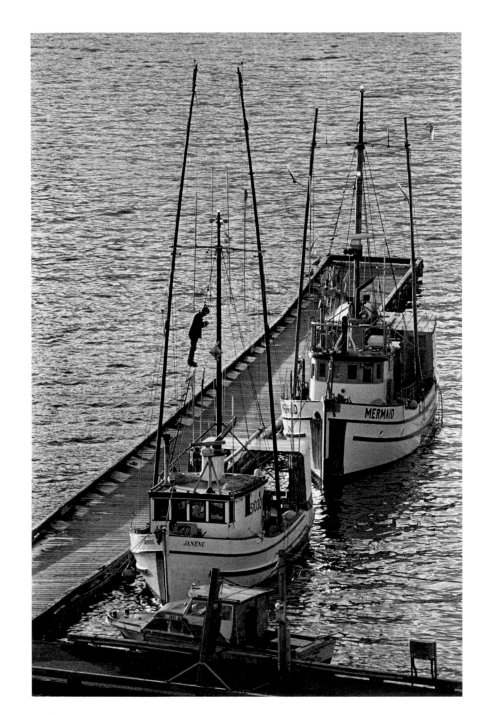

Rigging work on *Janene*,
Casey Moran boat harbor. 1990.

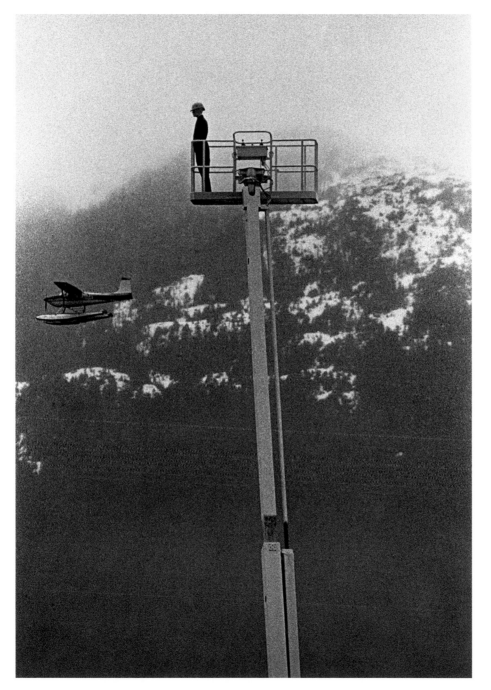

Manlift. March 17, 2000.

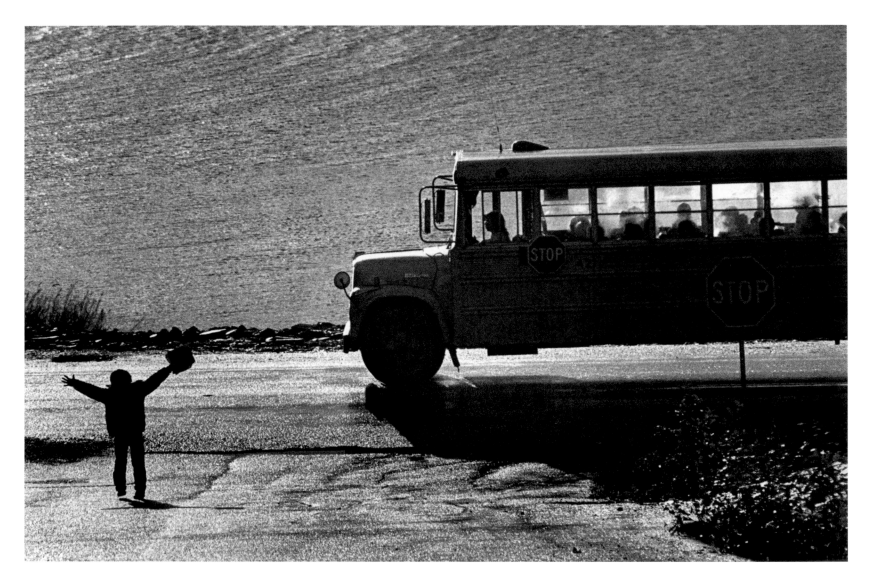

School's out, Saxman.
October 23, 1985.

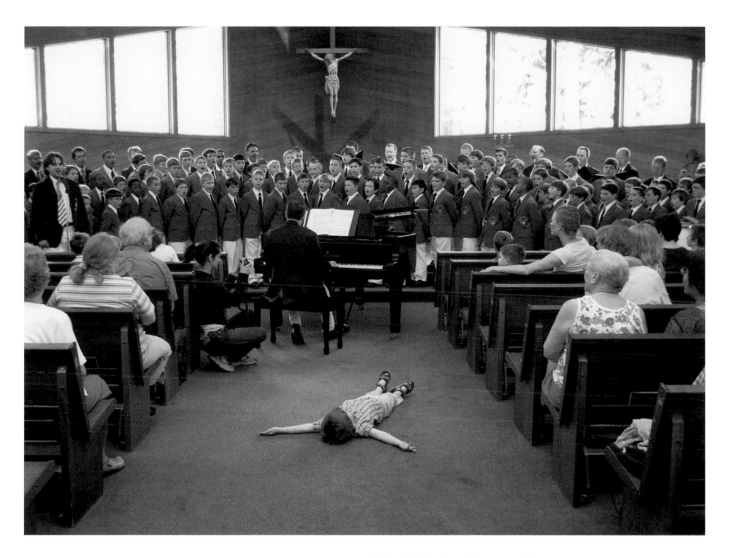

Philadelphia Boys Choir, Holy Name
Catholic Church. June 25, 2005.

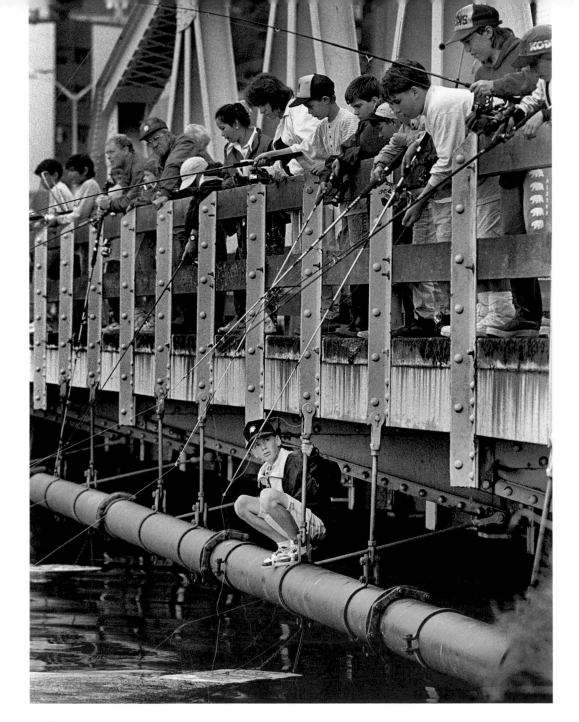

Stedman Street Bridge.
August 8, 1990.

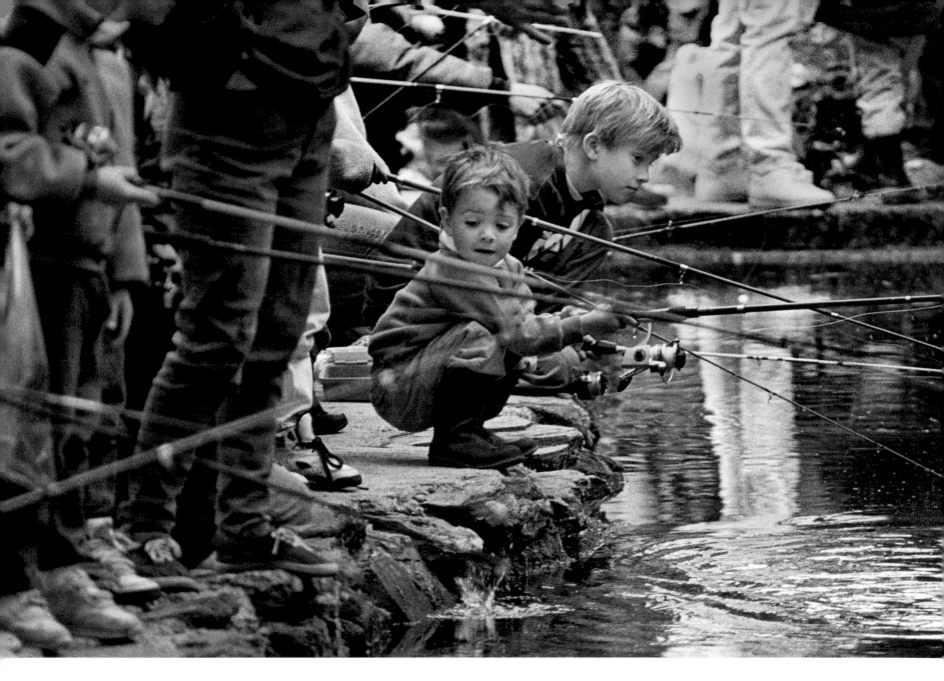

City Park Fishing Derby.
June 6, 1992.

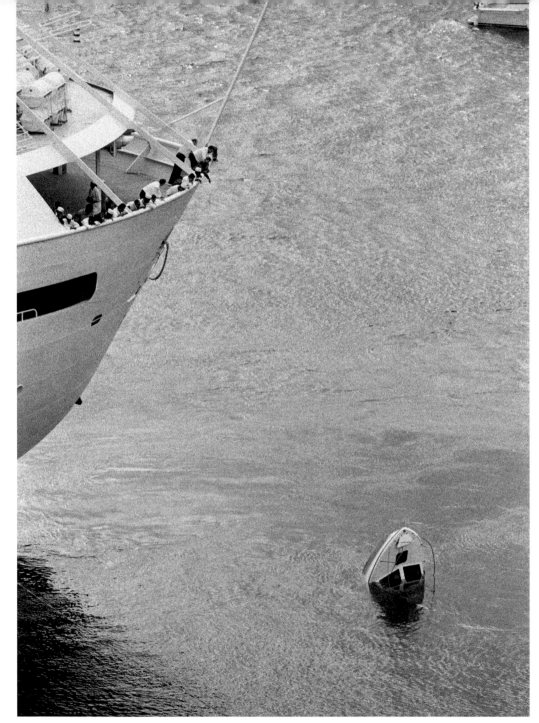

Capsized charter boat.
May 27, 1999.

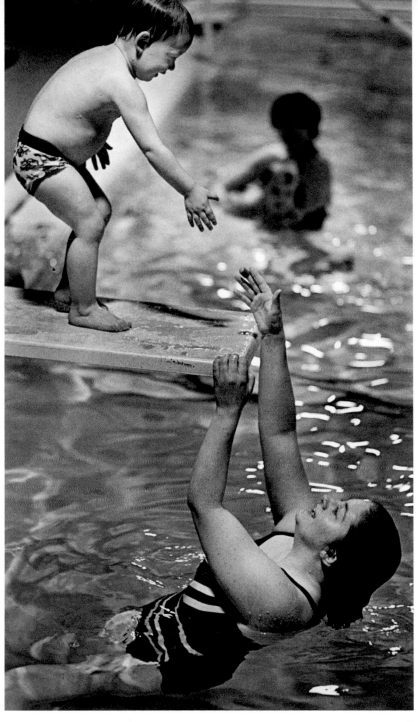

Aqua-tots, Valley Park pool.
February 27, 1987.

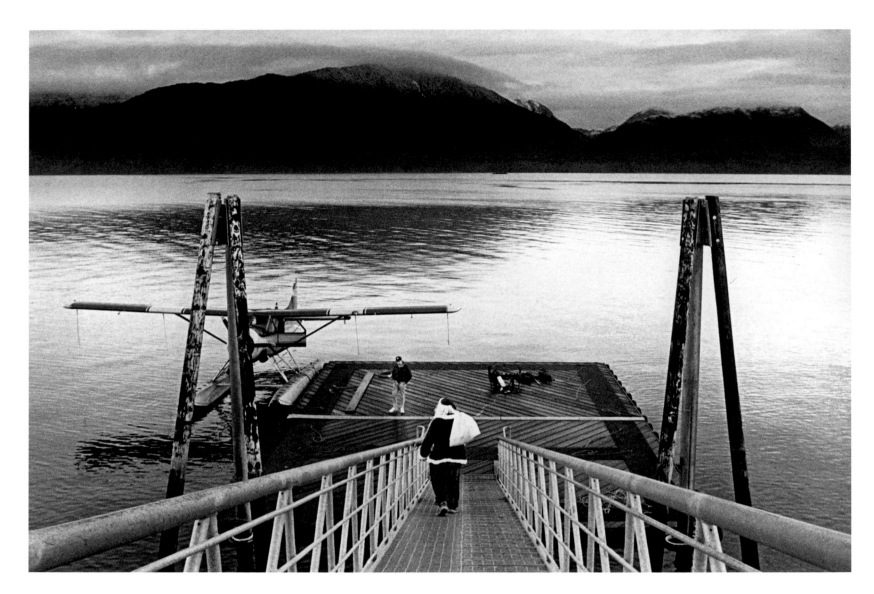

Floatplane dock, Metlakatla.
December 11, 1987.

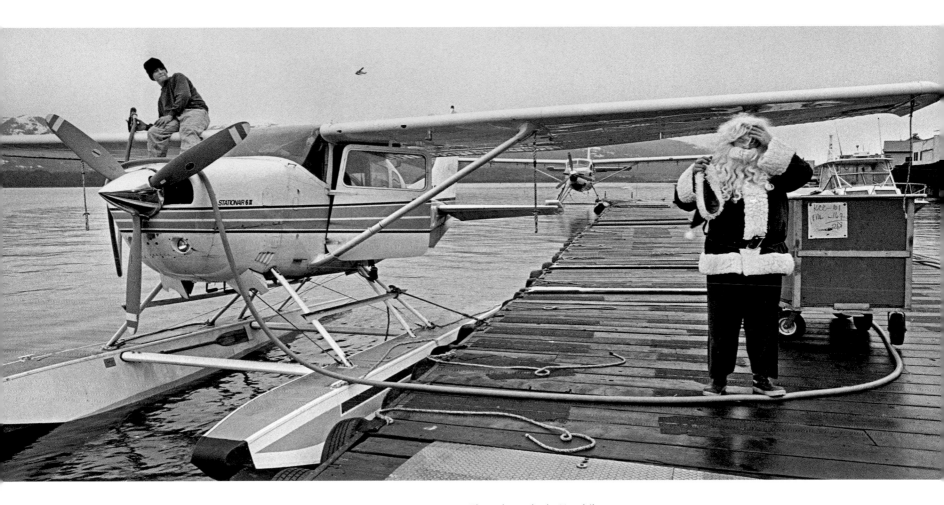

Floatplane dock, Ketchikan.
November 12, 1996.

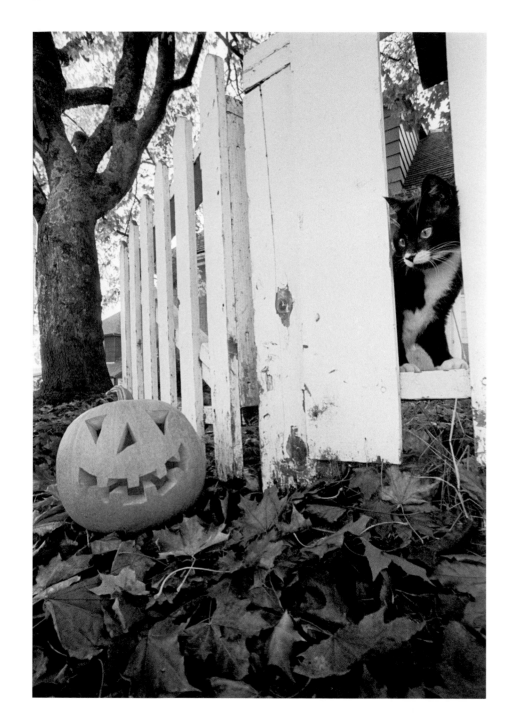

Halloween time, 445 Front Street.
October 22, 1987.

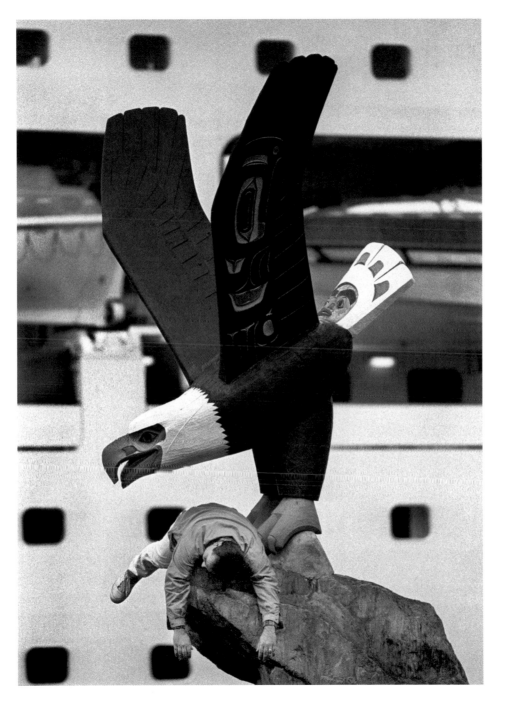

Eagle bait, Berth II Park.
September 10, 1993.

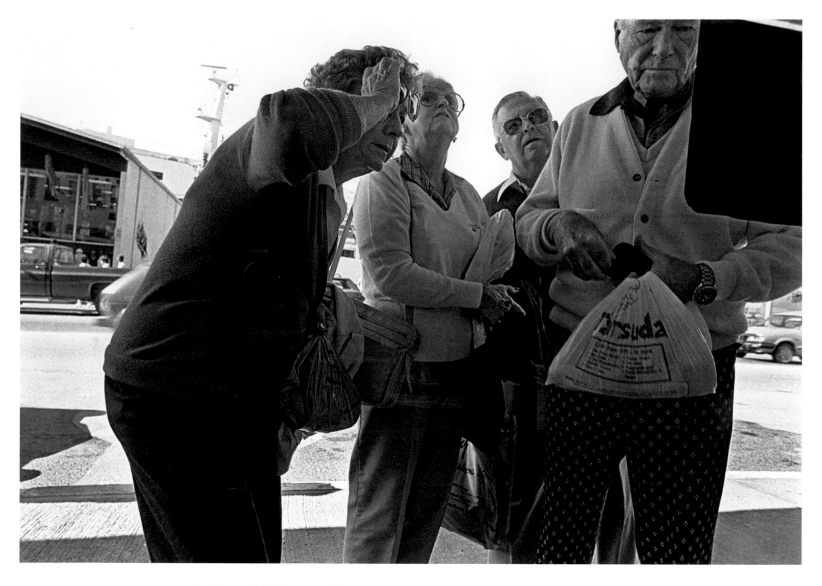

Tourists outside Gilmore Café.
August 29, 1986.

Parade Spectators.
Fourth of July, 1988.

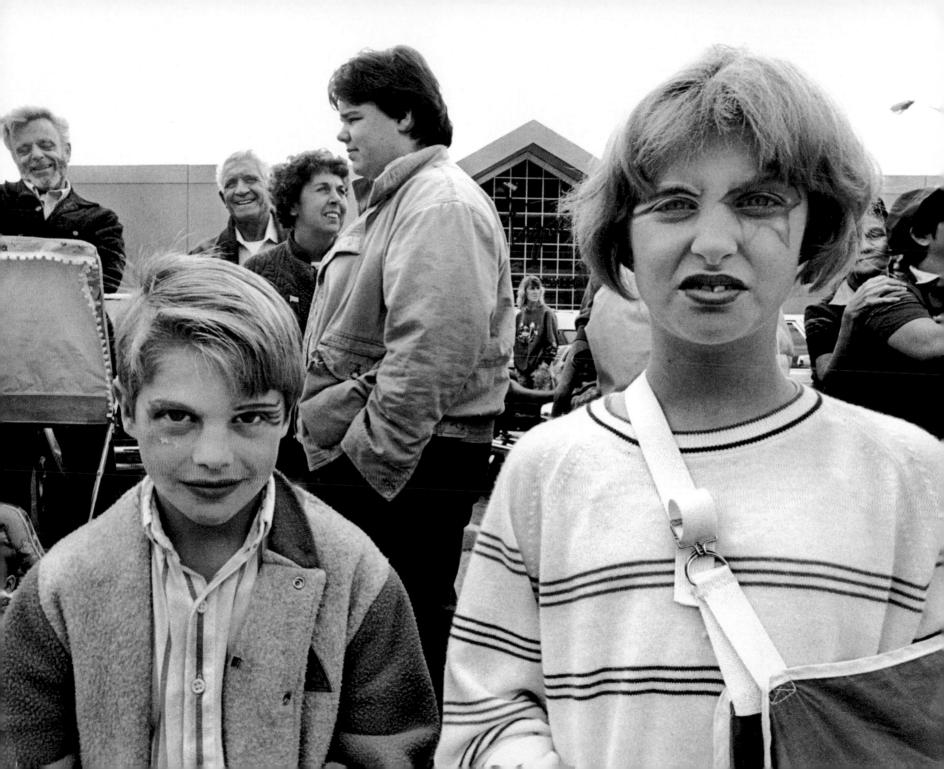

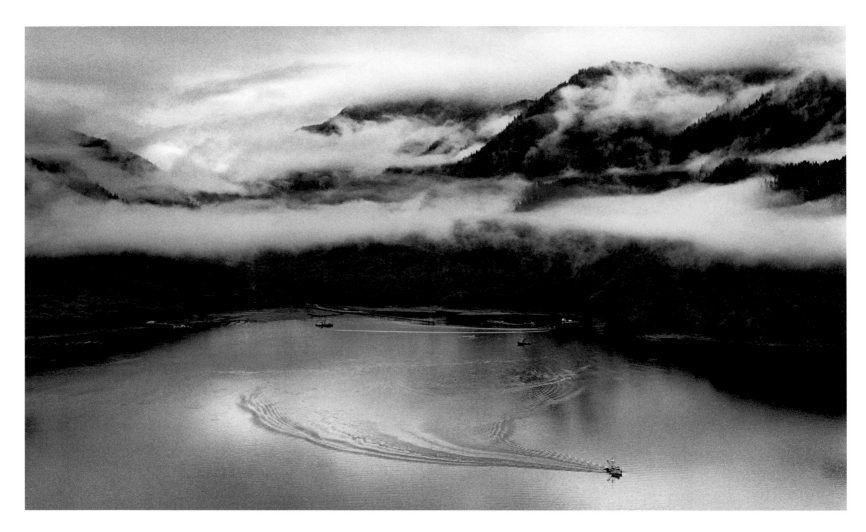

Fishing boat *Alsek*, Neets Bay.
September 21, 1990.

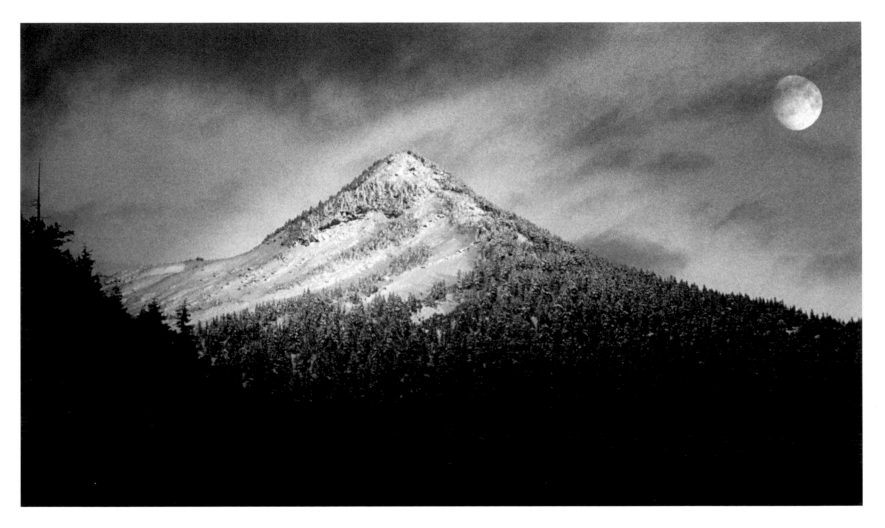

Moon over Deer Mountain.
October 30, 1990.

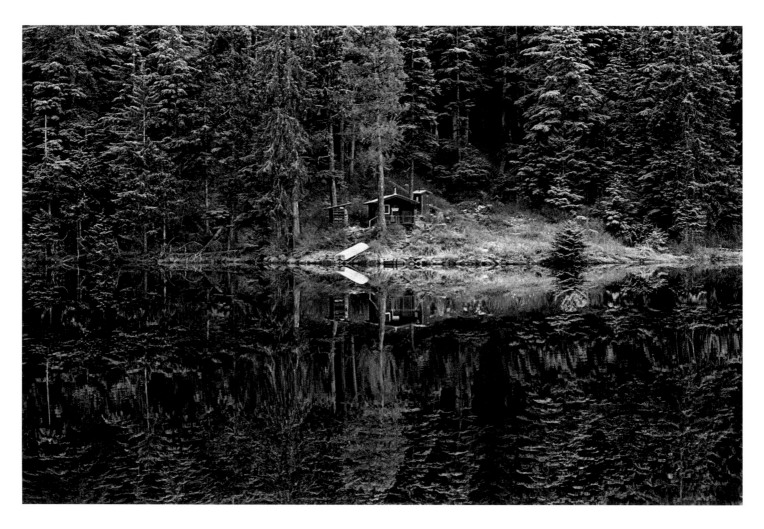

Reflection Lake. December 6, 1988.

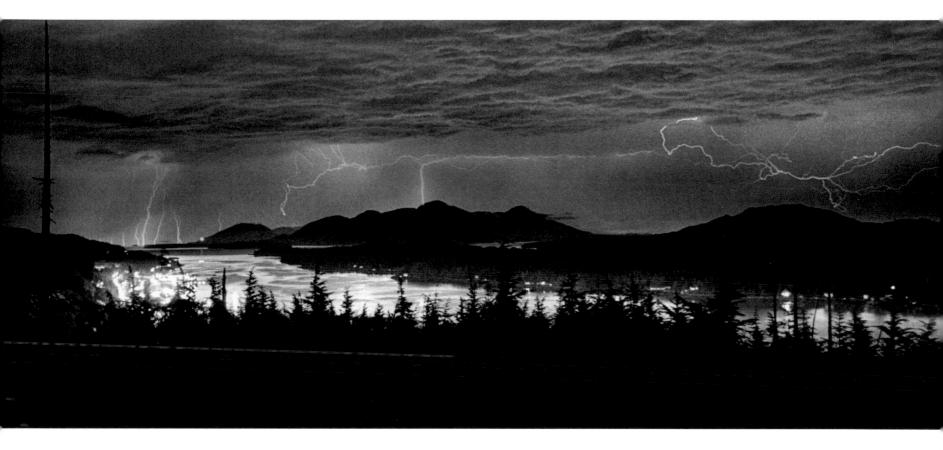

Electric sky. August 12, 1990.

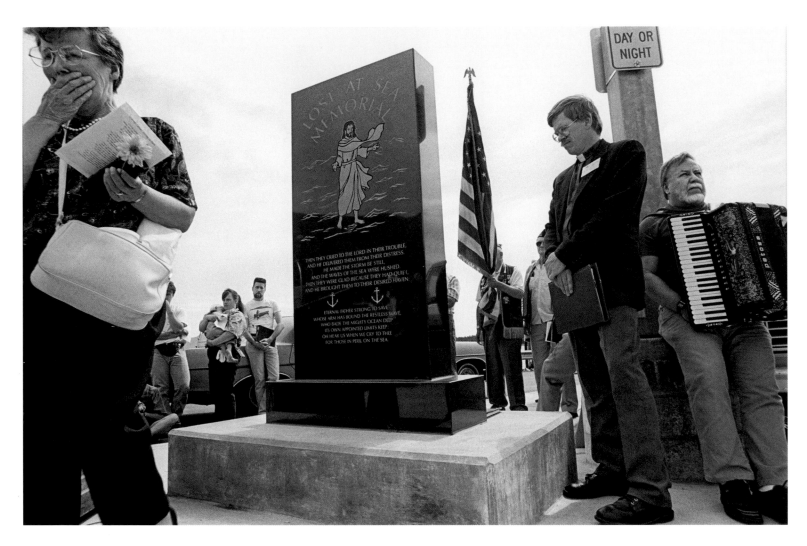

Lost at Sea Memorial.
May 31, 1993.

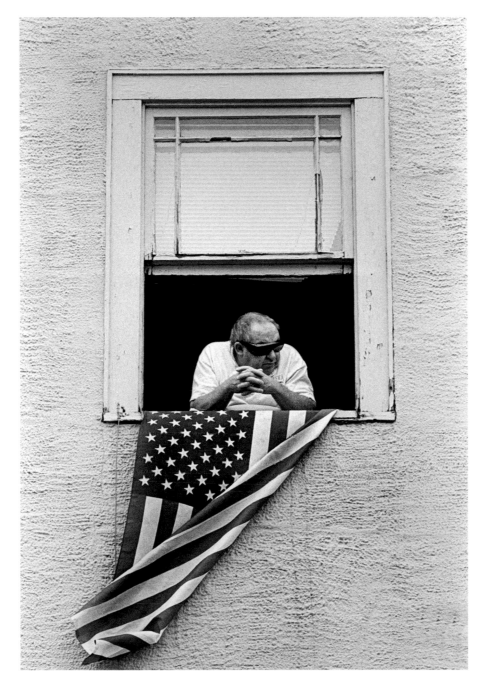

Spectator, Pioneer Hotel.
Fourth of July, 1988.

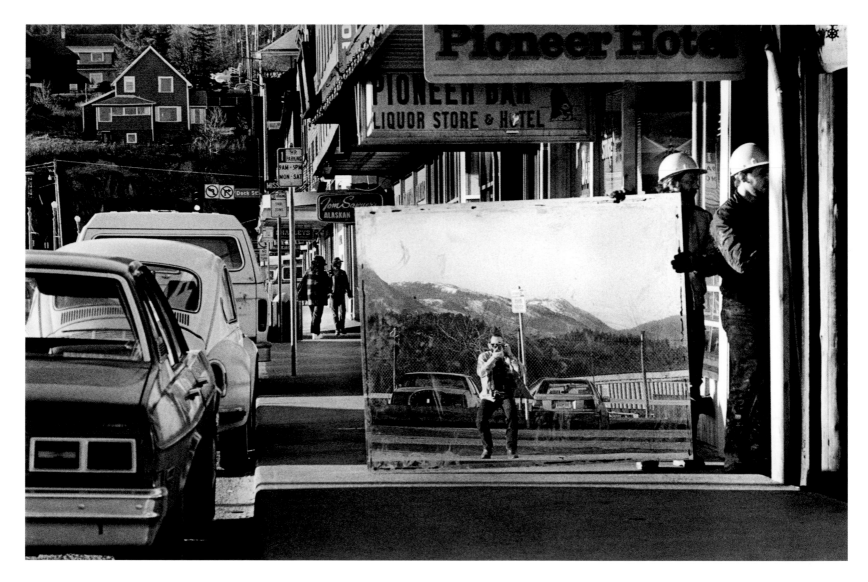

Self-portrait, Pioneer Hotel,
Front Street. March 15, 1989.

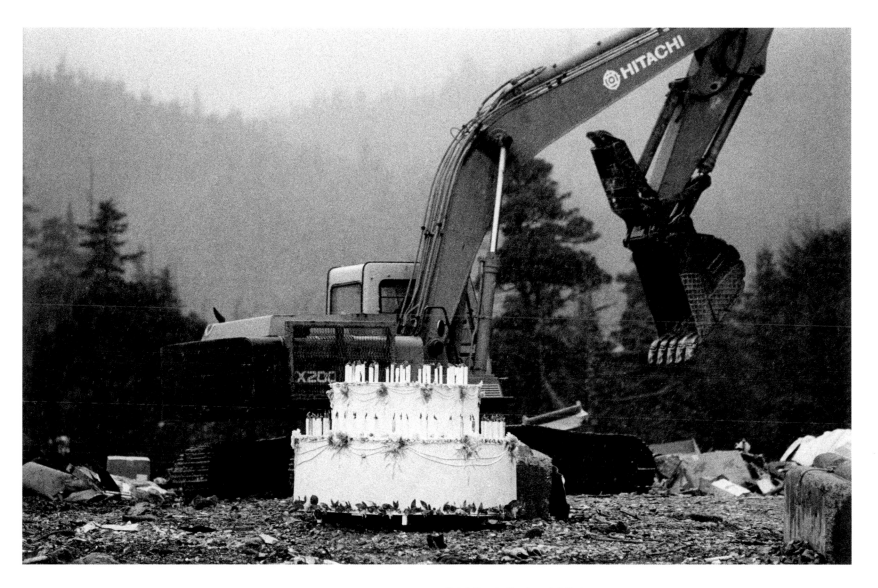

Ketchikan's Centennial Cake,
Ketchikan landfill. January 29,
2001.

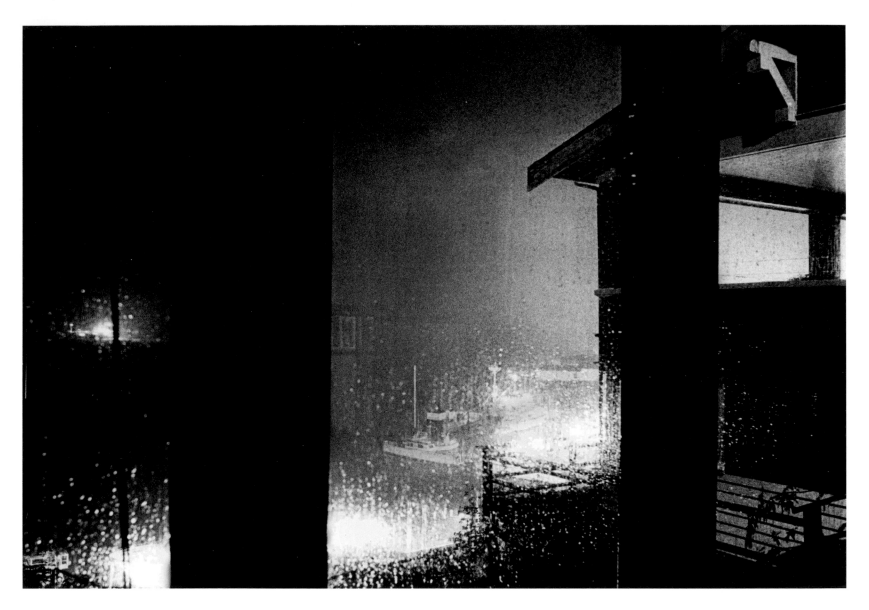

View from my window.
July 28, 1993.